Small Renaissance Bronzes

Small Renaissance Bronzes

Maria Grazia Ciardi Dupre

HAMLYN

Translated by Betty Ross from the Italian original

I bronzetti del Rinascimento

© *1966 Fratelli Fabbri Editori, Milan*

This edition © copyright 1970
THE HAMLYN PUBLISHING GROUP LIMITED
LONDON · NEW YORK · SYDNEY · TORONTO
Hamlyn House, Feltham, Middlesex, England

ISBN 0 600 01246 8

Text filmset by Filmtype Services, Scarborough, England

Printed in Italy by Fratelli Fabbri Editori, Milan

Bound in Scotland by Hunter and Foulis Ltd., Edinburgh

Contents

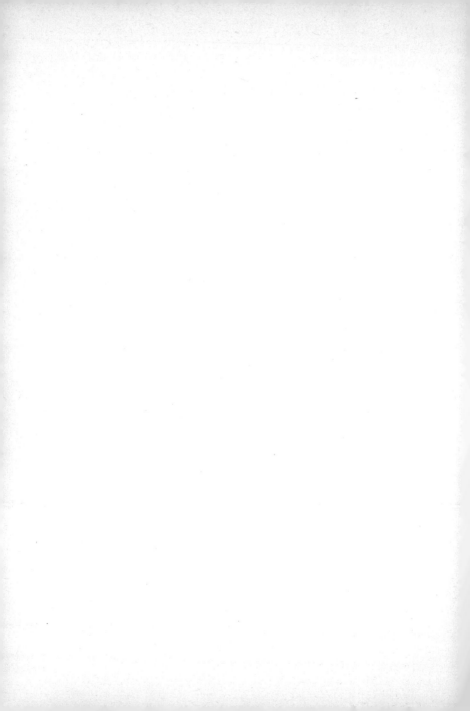

INTRODUCTION

A book about bronze statuettes must have a preface, short and self-evident though it may be. For unless the nature and the function of the statuette is clearly distinguished, it is impossible to appreciate fully the rich and varied development of the art at the time of its greatest magnificence, the Renaissance.

The very name 'statuette' indicates its most obvious characteristic, diminutive size; in every other respect it is the same as the largest bronze statue. Yet this particular difference is of greater consequence than might at first be supposed; for the question of scale is more fundamental in modelling and sculpture than it is in painting. The most distinctive quality of small sculptures is their extraordinary immediacy; they are seen close-to, so that there is almost no time-lag between the first look and comprehension of every part of the work. A great variety of design can be appreciated at once, since the modelling commands immediate attention; and at the same time there is an

almost total absence of the more awe-inspiring effects nearly always found in medium- or large-scale sculpture. This can be a real danger for the artist. His work is not judged by the same rigorous standards as the large statue, and so may easily degenerate into the conventional or pretty-pretty.

As the work is seen at very close quarters, the treatment of surfaces is important, and great richness and colour can be achieved by the modelling, or by the use of varnish and patina. The distinction between small and large bronzes is evident here. The large bronze, intended for display in the open air and more resistant to the effects of weather than either marble or soft stone, does not of course carry either varnish or patina, which are easily damaged. Gilding, which is quite resistant, can be used for works in fairly sheltered places, as on Ghiberti's Gates of Paradise for the Baptistry of Florence Cathedral. In small bronzes, on the other hand, patina and varnish are essential for the attainment of refinement; they also serve to eliminate all traces of raw edges and work carried out after casting. In the course of this book we shall see how the characteristics of varnish and patina vary from one workshop to another and from period to period.

Small bronzes are also very different from large ones in function and purpose. Cases in which bronze has been used instead of marble for practical reasons need not be considered here. (One such is the baptis-

mal font at Siena; bronze was used, regardless of expense, because marble would have been severely damaged by continual wear and tear.) Here we are concerned with the bronze statuette, the only purpose of which was to be an ornament in the study or drawing-room. Owing to the rapid development that took place during the last thirty years of the 15th century, it was soon to become one of those objects that satisfy the passion for collecting; indeed, Landais described small bronzes as 'collector's pieces', though such a definition is too narrow. In view of this, it is hardly surprising that the easily reproduced bronze statuette started a fashion that spread even into the middle classes, giving rise to a flourishing industry in moulded products of a taste and workmanship altogether commonplace.

The small bronze had another, and not dissimilar function: it was a cheap and portable 'souvenir' or imitation of a larger work. (It serves the same purpose today, catering for the needs of a public for whom a trip abroad may be an unrepeatable experience.) Thus bronze statuettes, like engravings of paintings, helped to spread the culture of the Renaissance.

A concomitant of the ease with which small bronzes could be perfectly reproduced by means of piece-mould casting was – and is – the prevalence of fakes and copies, which is a real hazard to students and collectors. Fakes are of two kinds. The first are copies of Classical works, made during the Renaissance; this

was often done in good faith for collectors unable to obtain genuine Classical works, which were of course in great demand. The second are later copies of bronze statuettes, generally those of the Renaissance; large numbers of these were produced, especially towards the end of the 18th and the beginning of the 19th century, when the outstanding quality of Italian Renaissance work was recognised. During this period, wealthy Europeans and Americans began to form private collections, and the great national collections – in, for example, the Kaiser Friedrich Museum, Berlin, and the Victoria and Albert Museum, London – were begun. Sometimes it is easy to distinguish a fake; when, for instance, a craftsman creates an original work in Renaissance style, he nearly always makes mistakes through not knowing enough about the history of art. But in most cases discovery is difficult because the fake is based on a known model; then only a real expert can spot the deception – perhaps through familiarity with the original model, or perhaps by recognising a technical anomaly. The weight of the piece may be wrong because the wrong kind of alloy has been used by the copyist. The technical knowledge required to recognise this is considerable; for although the most common alloy in Renaissance Italy – according to Vasari – consisted of two-thirds copper and one-third tin, it was by no means universal, and was certainly not the same in Florence as in Padua.

1 Bertoldo di Giovanni. *Orpheus*. 17½in. Museo Nazionale del Bargello, Florence.

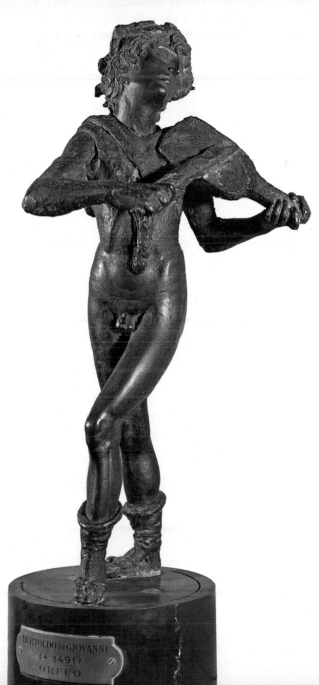

11

1 Bertoldo di Giovanni. *Orpheus*. 17½in. Museo Nazionale del Bargello, Florence. Cast by the *cire perdue* method, as can be seen from the special treatment of the surfaces. The face and legs are partly finished, except for the boots. This is, in effect, the first small bronze of the Renaissance, and one of its masterpieces, at once intimate, vigorous and expressive.

2 Donatello. *Amore-Atys*. 42in. Museo Nazionale del Bargello, Florence. Because of its size and purpose (the centrepiece of a fountain), this cannot properly be regarded as a statuette, but it was a very important landmark because it was based on Classical Greek statuettes. Noteworthy is Donatello's personal technique in finishing and virtually remodelling the bronze with the flogging chisel.

3 Donatello (attributed). *Dancing Cupid*. 15in. Museo Nazionale del Bargello, Florence. This cannot be said with absolute certainty to be by Donatello, but it is comparable with the three bronze statuettes he made for the baptismal font in Siena in 1428, and testifies to their importance in the history of bronze statuettes: while still forming part of a larger complex, they already compare with a statuette in size, subject matter and stylistic treatment.

2 Donatello. *Amore-Atys*. 42in. Museo Nazionale del Bargello, Florence.

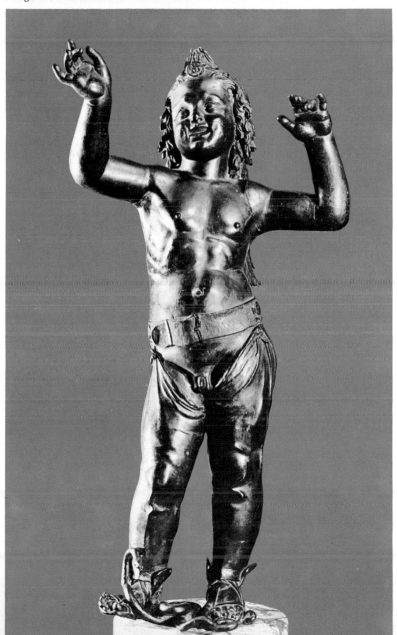

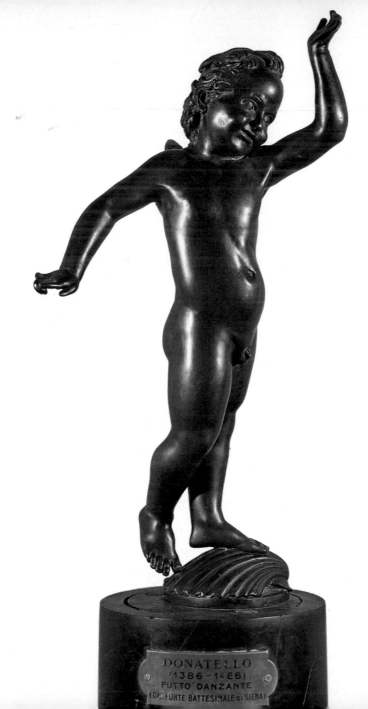

DONATELLO
(1386-1466)
PUTTO DANZANTE
(DAL FONTE BATTESIMALE DI SIENA)

It seems appropriate to conclude this introduction with a short technical account of casting. This is taken almost entirely from the notes of Vasari (introduction to the *Lives*) and Cellini. The basic procedure was to surround a wax model with clay, thus forming a mould. The mould was heated, so that the wax ran out, and molten bronze was poured into the space so created. When the bronze had cooled the mould was chipped away, revealing the statue or statuette.

Since solid casting (that is, making the statue entirely of bronze) was expensive and unsuccessful, the most commonly used method was as follows. The craftsman made a model in fire-clay that was the same size as the intended statue. This *anima* or 'core' was baked until it shrank about a centimetre, then covered with a layer of wax of roughly the 'missing' thickness. After the craftsman had given the wax a final modelling, threads of wax and bronze rods were attached to various parts of the model (they were to serve as channels and vents), which was thickly covered with fire-clay (the 'waste-mould'). The mould was heated, the wax ran out, and the bronze was poured in, forming a 'skin' around the core. As before, the mould was chipped away later and the statue was ready for finishing.

Before the end of the 15th century, several figures could be produced from one model. This was done by taking a 'piece-mould' of two or more sections from

3 Donatello (attributed). *Dancing Cupid*. 15in. Museo Nazionale del Bargello, Florence.

the model. A separate wax cast with a fire-clay core was made in the piece-mould, removed from it, and used to produce a bronze figure in the manner described in the previous paragraph. The piece-mould remained intact and could be used over and over again.

After the casting has been done, says Vasari, the finishing is carried out with 'the proper tools, to wit, graving chisels, burins, chasers, chisels, punches, flogging chisels and files'. The artist completes the modelling with these implements, and then 'polishes the whole diligently, giving it the final polish with pumice'. After the finishing, there is a third stage: putting on the patina. 'Some make it black by using oil,' Vasari continues, 'others use acid to make it green or give it a blackish colour by using varnish, each according to his own taste. But what is indeed a cause for wonder in our own times is the excellence of the casting of both large and small figures, many of the masters achieving such perfection that no tools have to be used to finish them . . . From which it may be seen that this art has now reached a greater state of excellence than ever it did in antiquity.' It should be noted that, of the three stages, only the finishing was done by the artist himself.

Besides the danger of fakes and imitations, the student of bronze statuettes is faced with another difficulty, namely the number and dispersion of these objects. Much can of course be learned by visiting

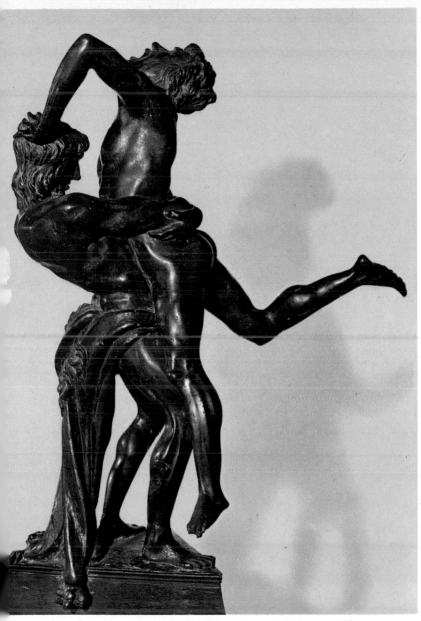

4 Antonio del Pollaiuolo. *Hercules and Antaeus*. 17½in.
Museo Nazionale del Bargello, Florence.

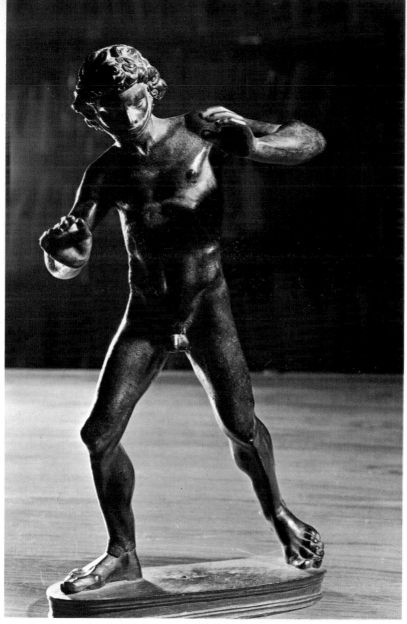

5 *Marsyas*. 14in. Italian, end of the 15th century. Galleria
Estense, Modena.

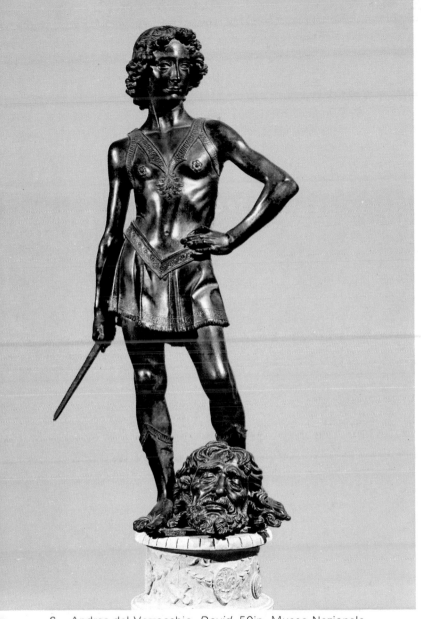

6 Andrea del Verrocchio. *David*. 50in. Museo Nazionale del Bargello, Florence.

4 Antonio del Pollaiuolo. *Hercules and Antaeus*. 17½in. Museo Nazionale del Bargello, Florence. Cast by the *cire perdue* method. Natural brown transparent patina under the black varnish. This statuette, intended to be the centrepiece of a fountain, soon found its way into 'the chamber occupied by Giuliano' in the Medici palace (1495 inventory).

5 *Marsyas*. 14in. Italian, end of the 15th century. Galleria Estense, Modena. Opaque black varnish. Often erroneously described as being 'of the Florentine circle of Pollaiuolo', this bronze is difficult to assess critically because it is clearly an imitation of a Classical model. This type of statuette in fact ended by passing as Classical. There are several replicas of this, one of them in the Bargello, Florence.

6 Andrea del Verrocchio. *David*. 50in. Museo Nazionale del Bargello, Florence. Not a statuette, of course; but it exemplifies the skill with which bronze was already being modelled and the considerable favour with which the material was regarded in the last decade of the 15th century.

7 Bertoldo di Giovanni. *Hercules on Horseback*. 11in. Galleria Estense, Modena. Black varnish on natural olive green patina. Originated in the Este collections and probably refers to Ercole I d'Este. It is certainly a table ornament; on either side it had a Hercules over a coat of arms, one of them now in the Liechtenstein Collection. Its lyricism is characteristic of early bronze statuettes, derived from Classical models and imbued with humanist feeling.

7 Bertoldo di Giovanni. *Hercules on Horseback*. 11in. Galleria Estense, Modena.

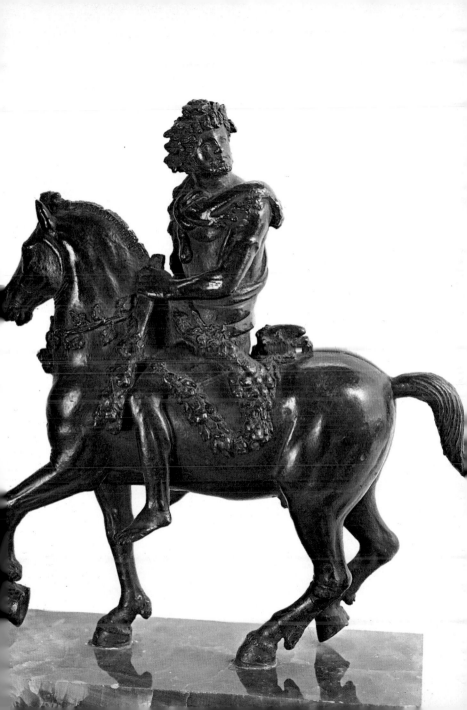

public collections. There are some very good ones in Italy. The best is at the Bargello, Florence, and there are others at the Galleria Estense, Modena; the Ca d'Oro, Venice; the Museo di Palazzo Venezia, Rome; the Museo di Palazzo Madama, Turin; and the Palazzo Schifanoia, Ferrara. There are excellent collections at the Kunsthistorisches Museum, Vienna; the Kaiser Friedrich Museum, Berlin; the Louvre, Paris; the Victoria and Albert Museum, London; and the Budapest Museum – not to mention the very fine American collections.

THE FIFTEENTH CENTURY: FLORENCE

A history of bronze statuettes must begin with Florence. The finest and most numerous were produced in Padua, and it was in Venice that the small bronze acquired independent status and popularity; but Florence was the birthplace of the art, and there it was logically developed. The art of Donatello (*c.* 1385-1466) contained the essential elements that were eventually to give rise to the creation of bronze statuettes. Donatello, the pupil and colleague of Ghiberti, the ablest master in bronze during the first half of the century, made bronze the vehicle of a life-like form of expression in large sculptures, revealing the amazing possibilities of this metal. In his *St Ludovic* (now in the Museo del'Opera di S. Croce,

Florence, but once in the niche of the Guelph party at Orsanmichele), bronze is not simply a substitute for marble – as it is in Ghiberti's statues for Orsanmichele, *St John the Baptist* (1414) and *St Matthew* (1419-1422). This statue displays Donatello's wonderful poetic imagination: the fragile adolescent is transformed into a symbol of power, the ornate ceremonial clothes stiffly enveloping his slim body and contrasting with the fragility of his face. It was Donatello, too, who first began to use ideas taken directly from Antiquity. On the *St Ludovic*, for instance, there is a garland of cupids, inspired by Antiquity if not directly imitated from it, which encircles the little temple at the top of the crook. A few years later, Donatello used this motif again, on a bigger scale and more conspicuously, in the dancing cupids around the rim of the baptismal font at Siena, where they are about half life-size.

These works are usually regarded as beginning the history of the bronze statuette because they are representations of an idea and have an obviously ornamental purpose. But they are not statuettes in the sense proposed here – that is, separate decorative objects. Only in his later work did Donatello begin to move decisively in that direction. With the *Amore-Atys* (Bargello, Florence), he created the first independent figure in bronze with a decorative function (plate 2). It was in fact the centrepiece of a fountain and carried on a Classical tradition which had never been lost, even during the Middle Ages. This new

development was prompted by a strong desire to imitate and outdo Classical art, as is demonstrated by the fact that, for the first time, the composition of a Greek figure is almost exactly reproduced. Yet not even the *Amore-Atys* – of which many rather indifferent bronze versions appeared towards the end of the century – can really be called a statuette; for it is life-size and, as part of a fountain, performed a specific function.

Donatello himself did not invent the bronze statuette as a distinct art form; but it was he who prepared the way, and who was responsible for the conviction that bronze was the best material in which the new ideas of sculpture – realistic and expressive,

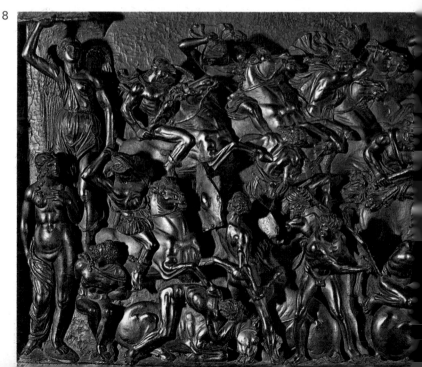

yet fanciful – could be realised. During the last thirty years of his life, he worked in soft materials, and especially in bronze. This is the material of the naked *David* in the Bargello, Florence; of the doors of the Sacrestia Vecchia of S. Lorenzo (the rest of the decoration is in terracotta and stucco); and of all the work done in Padua on the altar of the Santo and on the *Gattamelata* statue. Finally, Donatello used bronze for all the works he created after his return from Padua, from the *Judith* (again the centrepiece of a fountain) to the pulpit of S. Lorenzo. Donatello's indefatigable activity during these years brought into being a whole band of workers in bronze, not only pupils, but also technicians and metal founders,

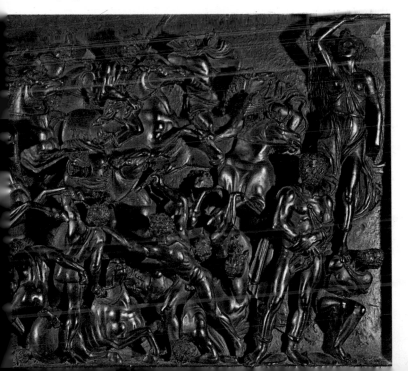

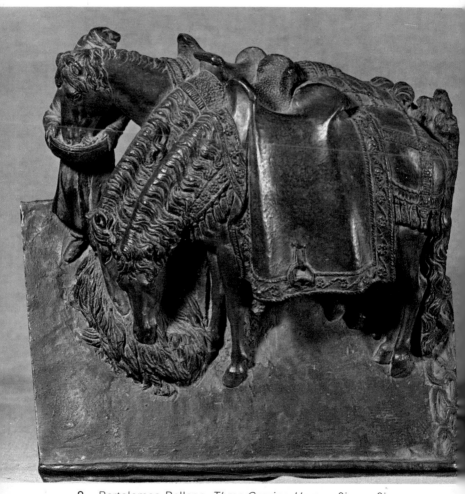

9 Bartolomeo Bellano. *Three Grazing Horses*. 9in × 9in.
Museo della Ca d'Oro, Venice.

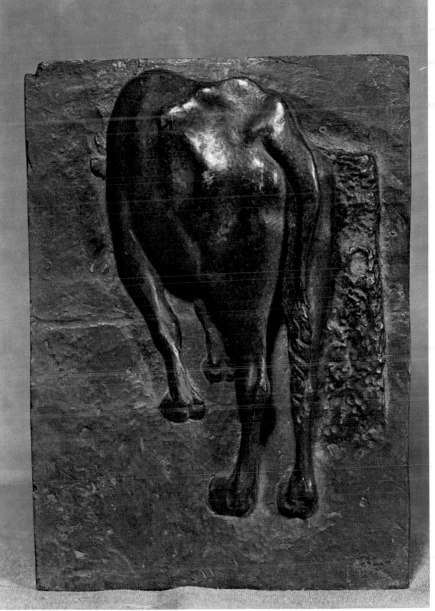

10 Bartolomeo Bellano. *Grazing Bull*. 7in × 5in. Museo della Ca d'Oro, Venice.

8 Bertoldo di Giovanni. *Battle*. 17in × 39in. Museo Nazionale del Bargello, Florence. Dark brown varnish on natural brown patina. This bas-relief is a splendid example of the humanist culture of the court of Lorenzo the Magnificent. It is derived from a sarcophagus now in the Camposanto at Pisa, but is a successful work of art in its own right.

9 Bartolomeo Bellano. *Three Grazing Horses.* 9in × 9in. Museo della Ca d'Oro, Venice. Dark brown varnish. Although unusually fluent and refined in workmanship, this plaque is attributed to Bellano because of its similarity to the Biblical stories of the Santo choir in Padua.

10 Bartolomeo Bellano. *Grazing Bull.* 7in × 5in. Museo della Ca d'Oro, Venice. Dark varnish. Like the *Three Grazing Horses,* this bas-relief came from the Mantoa Benavides Collection. They demonstrate that Bellano had already elaborated his discovery of animals as a naturalistic subject; this discovery was later exploited to the full by Riccio.

11 Andrea Briosco, known as Riccio. *Warrior on Horseback.* $9\frac{1}{2}$in. Victoria and Albert Museum, London. Black patina. From the Salting Collection. It is the masterpiece of Riccio's early period, and its style is still influenced by Bellano. This small bronze soon became famous because of the many replicas that were made; though of a somewhat inferior quality, they are regarded as contemporary.

11 Andrea Briosco, known as Riccio. *Warrior on Horse-back*. $9\frac{1}{2}$in. Victoria and Albert Museum, London.

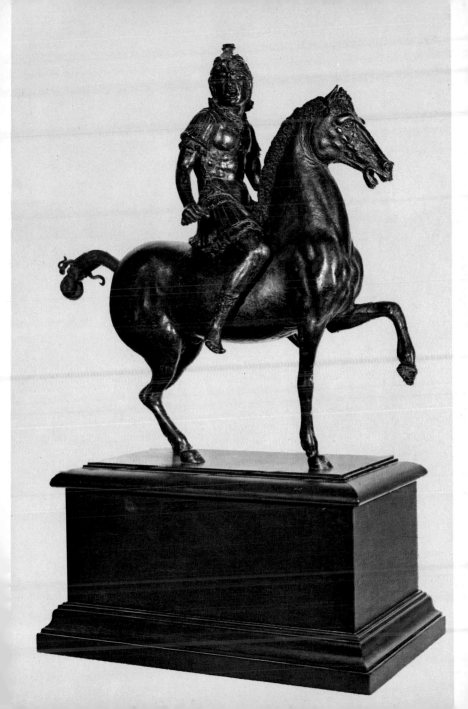

masters of a new technique which was less one of foundry work than of finishing. The sculptural tradition of Padua, which had been derived from a deep-rooted tradition in Venice, was transplanted to Donatello's workshop. It was under his influence that bronze began to be used almost to the exclusion of marble in the works of Florentine sculptors of the middle of the 15th century.

First among these were Pollaiuolo and Verrocchio. They did not create bronze statuettes proper (except for Pollaiuolo's *Hercules and Antaeus*, which will be considered later), but both appreciated the new values that bronze could offer. Verrocchio (1435-1488) used bronze to give a feeling of lightness and freedom, as of a beating of wings in the surrounding half-light to his *Cupid with Dolphin*, which surmounts the fountain in the courtyard of the Palazzo Vecchio, Florence (once a fountain the Medici villa at Careggi). With the same material he created an effect of translucent shadow on the figure of David in the Bargello (plate 6); and gave a matt surface – suggesting absence of light – to the secret colloquy between Christ and St Thomas (in a niche at Orsanmichele).

Bronze was the only possible material that Pollaiuolo (1433-1498) could have used to carry out his strange interpretation of Donatello's vision. This was an almost abstract analysis of shapes which were not (as with Donatello) integrated with the background, but isolated in front of it, as though on a blank screen.

Extreme examples of this procedure can be seen in the figures and bas-reliefs on the Roman tombs of Sixtus IV and Urban VII. The separation of figures from their background freed artist and spectator from the restraint imposed by a single view of movement. This is at once evident in the small group *Hercules and Antaeus* (plate 4), which is the model for the centrepiece of a fountain (never carried out) for a Medici villa. This bronze group, extremely bold in its manner of representing movement and with a tension and vigour derived from the play of light on the facetted surfaces, is of enormous importance in the history of bronze statuettes. It was the first bronze object made for purely aesthetic purposes, and first indicated the possibilities afforded by a small-scale work for concentration and richness of design. Furthermore, the *Hercules and Antaeus* demonstrated the self-sufficiency of isolated figures, not only as beautiful shapes, but also in their ability to convey life and movement. No small bronzes can with certainty be attributed to either Pollaiuolo or Verrocchio, however; indeed, the attributed *putto* or cupid in the Straus Collection in New York is definitely not by Verrocchio, for the style is different from his. Neither the *Hercules* in the Frick Collection in New York, nor that in Berlin, are by Pollaiuolo, for they differ from the artist's authenticated work. The *David* in the Museo Nazionale, Naples, was wrongly attributed to him by Venturi, as was recently recognised at an exhibition of small

bronzes of the Italian Renaissance held in 1962.

In the Florence of the second half of the 15th century, conditions existed favourable to the appearance of small bronzes. In the year before Donatello's death in 1465, the first bronze statuette proper was made. This was a small copy, about 20in high, of the equestrian statue of Marcus Aurelius which was at that time one of the best-known sculptures of Antiquity; the copy was made by Antonio Filarete (1400?-1469?), and dedicated to Piero de' Medici in 1464. The style of the statuette is similar to that of Filarete's late work, and this agrees with the date of the inscribed dedication. Filarete's *Marcus Aurelius* (now in the Albertina at Dresden), being a copy, has only limited artistic value; but from the cultural point of view it is very important because it marks the beginning of the bronze statuette as a form of art in its own right: it is related to a Classical model, and it also exemplifies one function of the small bronze in that it is a reproduction of a larger work.

A distinction must be made between a reproduction or copy and the statuette as an independent artistic creation. It is in the second of these fields that we find Bertoldo, with Bellano the inventor (so far as is now ascertainable) of the small bronze as an independent artistic product on a small scale. Bertoldo's claim is supported by Vasari's comments on his great reputation. 'In Florence at that time, there was none that could surpass him in the skill apparent in all the casts

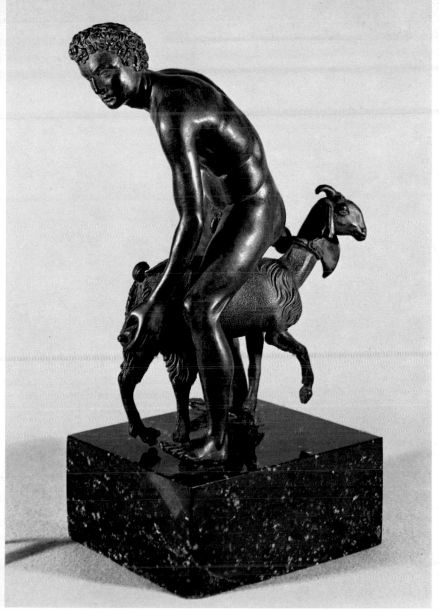

12 Andrea Briosco, known as Riccio. *Herdsman with Goat*. 10in. Museo Nazionale del Bargello, Florence.

12 Andrea Briosco, known as Riccio. *Herdsman with Goat.*
10in. Museo Nazionale del Bargello, Florence. This exquisite
little bronze (there is only the one model of it), is faultlessly
made; it was certainly commissioned by an important and
exacting patron. The Bargello acquired it from the Carrand
Collection. Although regarded by some as an early work, it is in
fact a late one, as the fineness of the modelling shows.

13 Andrea Briosco, known as Riccio. *Negro Astride a Goat.*
8½in. Barber Institute of Fine Arts, Birmingham. Dark brown
patina. Although the attribution to Riccio has often been
questioned, this statuette undoubtedly belongs to the artist's
circle. This bronze must have served some special purpose, for
the negro boy is carrying a shell on his shoulders.

14 Andrea Briosco, known as Riccio. *Seated Pan.* 7½in.
Ashmolean Museum, Oxford. Dark patina. One of the
masterpieces of Riccio's late period, as the splendid modelling
shows. Its function as an inkstand has been disguised;
attention is distracted by the realistic-psychological rendering
of the drunken god.

15 Andrea Briosco, known as Riccio. *Male and Female
Satyrs.* Victoria and Albert Museum, London. This highly
original group is another masterpiece of Riccio's maturity.

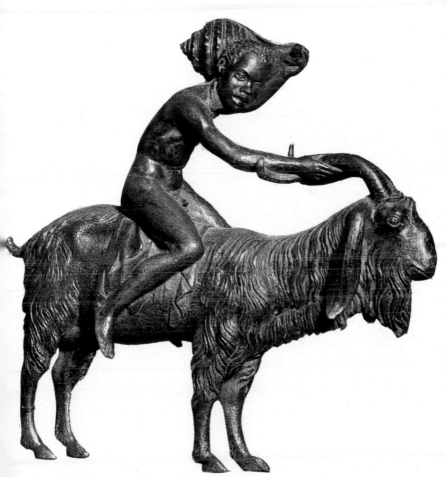

13 Andrea Briosco, known as Riccio. *Negro Astride a Goat*. 8½in. Barber Institute of Fine Arts, Birmingham.

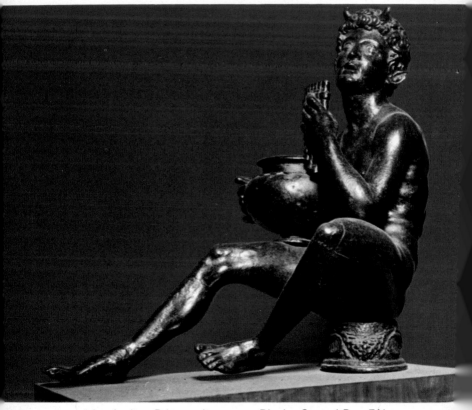

14 Andrea Briosco, known as Riccio. *Seated Pan.* 7½in.
Ashmolean Museum, Oxford.

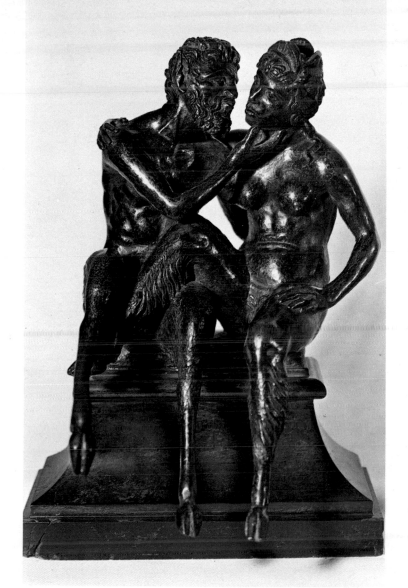

15 Andrea Briosco, known as Riccio. *Male and Female Satyrs*. Victoria and Albert Museum, London.

he had made in bronze of battles and of a number of small things.'

Bertoldo (1420-*c*.1491) was a pupil and colleague of Donatello in the later stages of that master's career. Vasari records that Bertoldo had 'diligently worked at finishing the casts of his master Donato's pulpits' for San Lorenzo; they were Donatello's last works, and remained unfinished when he died. A large number of small bronzes are known to be by Bertoldo's hand. Some are signed or documented, others can be attributed to him with certainty by comparing them with known works. The following are especially worthy of notice, since they are completely authenticated. The signed *Bellerophon and Pegasus*, now in the Kunsthistorisches Museum in Vienna, originated in Padua and can therefore be dated between 1483 – when Bertoldo was given the commission for two bas-reliefs for the choir of the Basilica del Santo – and 1486, when Bertoldo ended his collaboration with the Florentine Adriano, who as foundryman signed the *Bellerophon*. The very lovely bronze relief of the *Battle of the Centaurs* (plate 8) was once the property of Lorenzo the Magnificent, and is now in the Bargello, Florence. It is in the same style as some of Bertoldo's authenticated bronzes, for example, the *Hercules on Horseback* (plate 7) probably executed for Ercole I d'Este, *Hercules and the Club* (Berlin Museum), and *Hercules Resting on a Shield* (Liechtenstein Collection, Vaduz) – all measuring between 8in and 12in;

and the *Arion* (plate 7) and *Apollo* in the Bargello, Florence ($17\frac{1}{2}$in).

This group of small bronzes, all similar in size to the *Battle,* differs from the *Bellerophon,* which is smoother and more polished – an indication, perhaps, of the foundryman Adriano's intervention in both the first stages and the finishing. These statuettes reveal Bertoldo's personality in its most lyrical aspect. They are executed in a new manner that is simple and harmonious, displaying a cultivated yet rustic Classicism which must have been particularly in sympathy with the lyrical temperament of Lorenzo the Magnificent, to whom Bertoldo was a companion and friend. Bertoldo's Classical knowledge is unquestionable. It is evident in the *Battle of the Centaurs,* which is a free adaptation of a battle scene on a stone coffin in the Camposanto at Pisa; Bertoldo also drew on other remembered sources, an important one being the *Fighter* in the Musei Capitolini, Rome.

This again demonstrates the connection between the production of small bronzes and the strong Classical trend in Florentine culture at the time of Lorenzo the Magnificent. The very notion of the statuette as an independent creation to be enjoyed in the solitude of a study (itself a Renaissance innovation as a place of intellectual enjoyment) derived from two different factors: the desire, particularly widespread among cultivated amateurs, to possess Classical works in the form of small bronzes; and the

16 Andrea Briosco, known as Riccio. *Sphinx*. 19in.
Victoria and Albert Museum, London.

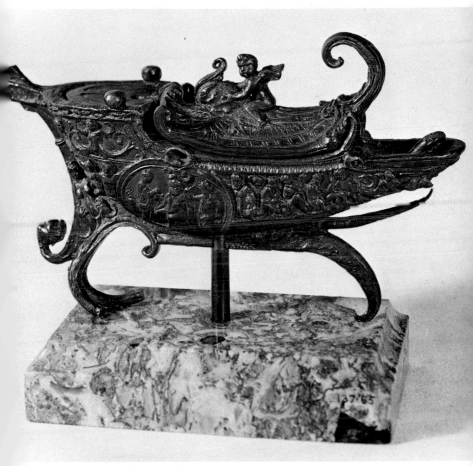

17 Andrea Briosco, known as Riccio. *Lamp in the form of a boat*. 5in × 8½in. Victoria and Albert Museum, London.

16 Andrea Briosco, known as Riccio. *Sphinx*. 19in. Victoria and Albert Museum, London. Thick dark patina. Intended to serve as andirons or perhaps as a table support; it came from the famous Paduan Obizzi al Cataio Collection. Riccio's hand is evident in these sphinxes, which are related to the work on the Santo candelabrum.

17 Andrea Briosco, known as Riccio. *Lamp in the form of a boat*. 5in × 8½in. Victoria and Albert Museum, London. Dark patina. This magnificent example of applied art again demonstrates the boldness of Riccio's imagination; it anticipates the capricious decorative elegance of certain 16th-century Mannerist goldsmiths. There are other, slightly different examples of this model.

18 Riccio's workshop. *Lamp in the form of a satyr's head*. Nearly 3in. Galleria Estense, Modena. Because of its rough workmanship this piece cannot have been made by Riccio himself. Although bizarre in appearance, the lamp is a simple enough piece.

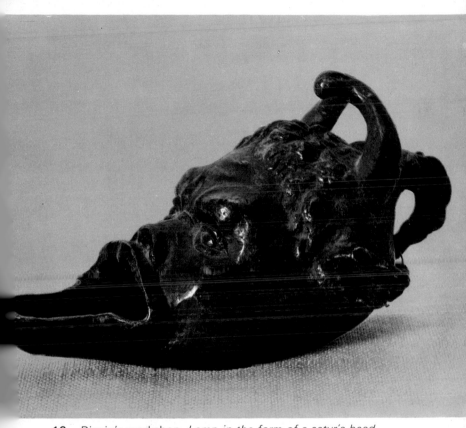

18 Riccio's workshop. *Lamp in the form of a satyr's head.*
Nearly 3in. Galleria Estense, Modena.

tendency of scholars and artists to retreat from reality, surrounding themselves with objects to their own taste. This Florentine culture, a mixture of Classicism and Ficino's Neo-Platonism, was epitomised by the Academy set up by Lorenzo the Magnificent in the gardens of San Marco, Florence. Bertoldo was the director of the Academy, whence Michelangelo, his greatest pupil, largely drew his intellectual nourishment.

Despite his ties with the highly cultivated circles around Lorenzo, Bertoldo never lost the lyrical impulse which usually found expression in a formal simplicity very much akin to that of the Paduan sculptor Bellano. In his *Orpheus* (plate 1) the clear, simple gesture of striking the instrument is matched by the controlled energy of the first step in the dance; the expression is absorbed and ecstatic, the eyes large and melancholy. Likewise, the *Hercules* (plate 7) in the Galleria Estense, Modena, a hero adorned with garlands, turning to acknowledge an ovation, does not seem to be taking part in a great public ceremony, but in a rustic and peaceful celebration.

Bertoldo differed from both his contemporaries and later artists in that he was able to master Donatello's precepts on the subject of finishing. These entailed the use, not of the customary goldsmith's technique, but of that of the sculptor; the chisel was employed and surfaces were left rough where such treatment seemed called for. With less vigour and impetuosity than

Donatello, perhaps, Bertoldo made use of this technique to create surfaces of luminous beauty, to give an intense, yet distant and dreamy expression to eyes, and, with a few strokes, to produce a mesh of hair that absorbs the light which glides off more polished areas. He always followed Donatello in using a brown patina rather than varnish.

Bertoldo's school, which had so great an influence on the young men who frequented it, was equally – though briefly – influential in stimulating the art of small bronzes. Thus, in a field only just emerging from long neglect, there was another exceptional individual: the Florentine Adriano, who has already been mentioned as Bertoldo's foundryman. Adriano di Giovanni dei Maestri (1440/50-1499) was a medallist and the sculptor of life-size busts, but he also made small bronzes. There is a *Venus* signed by him in the Foulc Collection in Paris which shows how close his style was to that of Bertoldo.

It is improbable, however, that many Florentine bronze statuettes later than Bertoldo will come to light. The premature extinction of the art must be attributed to Michelangelo's influence. Anything on a small scale was completely alien to his personality – and that personality dominated Florentine art during the early decades of the 16th century. The only exceptions were a few artists, who will be discussed later, whose training links them with the school of St Mark's.

THE FIFTEENTH CENTURY: CENTRAL ITALY

The difficulty of studying small bronzes has been described in the introduction. The result is that the work of critical survey – which is continuous and subject to constant revision in every branch of art history – has been retarded in this particular field. Minor schools and artists have been the most neglected – 'minor' in this case implying no lack of imaginative power, but rather a style without strongly-marked traits, or outside the main tendencies of the period.

This has happened to Sienese Renaissance sculpture, for example, though it is extremely beautiful and boasts artists like Il Vecchietta, Neroccio and Francesco di Giorgio Martini. Although Il Vecchietta and Francesco di Giorgio worked mainly in bronze, there is not a single statuette that can confidently be identified as their work. The few attempted attributions, mainly to Francesco di Giorgio (1439-1501) – for example a *David with Goliath's Head* (Kaiser Friedrich Museum, Berlin) and an *Arion* – have been rejected by critics in recent years.

It is true that in recent years an attempt has been made to determine as Sienese small bronzes hitherto considered Florentine. One such attempt was made at the exhibition of small Italian bronzes held in London, Amsterdam and Florence in 1961 and 1962. The

famous *David* in the Museo di Capodimonte, Naples was attributed to Francesco di Giorgio Martini; previously it had been unanimously accredited to Antonio del Pollaiuolo. Another example is the statuette of St John the Baptist (Louvre, Paris), which was generally considered the work of Bertoldo; it is now attributed to Il Vecchietta. Despite the assent of important authorities, these suggestions should be treated with caution, for the similarity in style between these pieces and known works by the artists in question, is far from established. If the Capodimonte *David* is compared with bronzes known to be by Martini, it becomes evident that the unfinished surfaces on *David* have a quite different purpose from those on Martini's bas-reliefs (for example the *Flagellation* in the Galleria Nazionale, Urbino). On the bas-reliefs the object is not to give rounded modelling to muscular forms, but to bring out fragile and restless figures against an indefinite and hazily luminous background. And where the figures are in the round (the *Angels* in the tabernacle of Siena Cathedral, or the *St John the Baptist* at Fogliano) the purpose of the modelling is fuller use of light effects, not – as in the *David* – definition of outline. A certain number of small plaques and plates in bronze by Francesco di Giorgio have, however, survived; for instance, the pair representing St Sebastian and St John the Baptist in the Washington National Gallery (Kress Collection). Small bronzes and plaques were

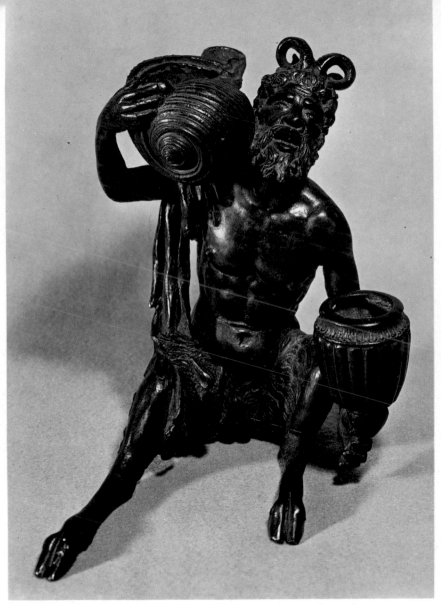

19 Andrea Briosco, known as Riccio. *Seated Satyr*. 8in. Museo Nazionale del Bargello, Florence.

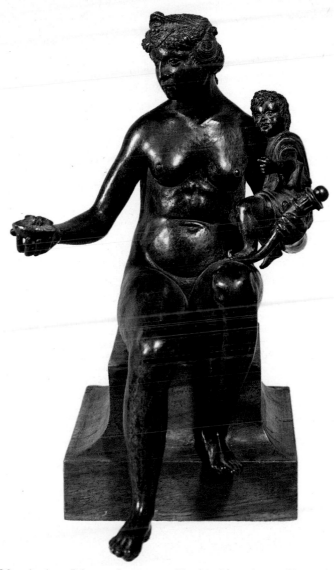

20 Andrea Briosco, known as Riccio. *Abundance*. 9in.
Museo Nazionale del Bargello, Florence.

19 Andrea Briosco, known as Riccio. *Seated Satyr.* 8in. Museo Nazionale del Bargello, Florence. This is one of the masterpieces of Riccio's mature period. Various replicas are known, mostly of workshop origin. In no other instance did he invest with so much moral seriousness an object destined for common use (in this case an inkstand).

20 Andrea Briosco, known as Riccio. *Abundance.* 9in. Museo Nazionale del Bargello, Florence. One of the most famous of all bronze statuettes, utilising all the creative and expressive possibilities of the art. Myth and nature, truth and beauty, are blended with a spontaneity rarely found in monumental sculpture.

21 Severo da Ravenna (or the Master of the Dragon). *Pluto with a Dragon.* 22in. Museo Nazionale del Bargello, Florence. This artist was the creater of a group of bronzes in each of which a dragon appears. His style is old-fashioned, in the manner of Bellano, but he appears to have absorbed the mythological and metamorphic subject-matter introduced by Riccio.

22 Desiderio da Firenze. *Electoral Urn.* Museo Civico, Padua. This urn was cast in three parts. It was made between 1532 and 1533, by a sculptor who is still little known. Desiderio evidently worked in the early 16th-century Paduan style, but was familiar with the breadth and complex use of light and shade of Tuscan work.

21 Severo da Ravenna (or Master of the Dragon). *Pluto with a Dragon.* 22in. Museo Nazionale del Bargello, Florence.

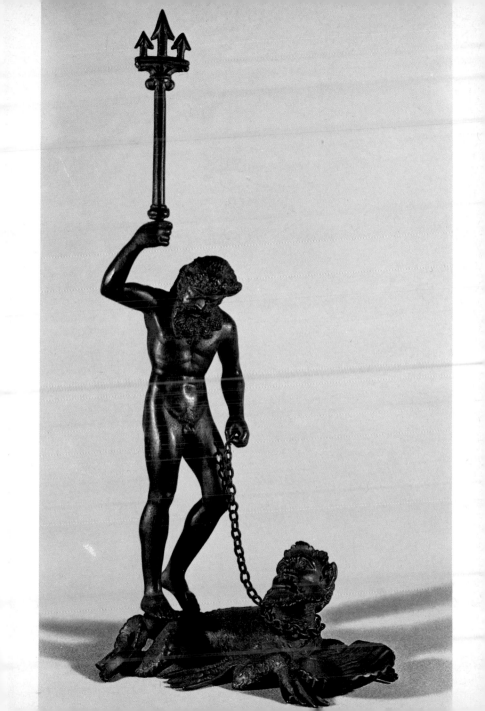

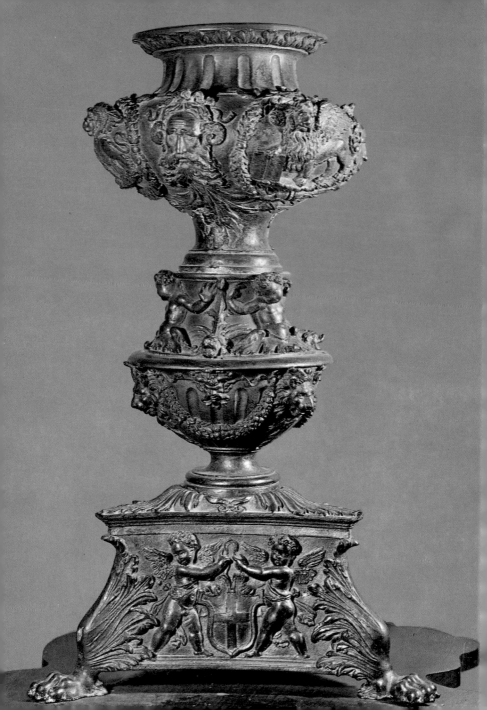

also almost certainly made by Il Vecchietta (1412-1480), who created statues and bas-reliefs in the same metal; but as yet no small bronzes by him have been found.

During the Renaissance, bronze enjoyed a great vogue in Siena under the influence of the Florentines, and in particular of Donatello, who stayed there in 1458 and is said to have worked for the city; he left some of his major works there, for example the early bas-relief *Salome's Dance* in the Baptistry, and the late *St John the Baptist* in the cathedral. His example was a fruitful one, since favourable conditions already existed in Siena as a result of the great 14th-century tradition of goldsmith's work.

Nothing of any note in this field occurred in other parts of central and southern Italy during the 15th century; there are almost no important works in bronze, and local tradition was non-existent, as were foundries with skilled workers.

THE FIFTEENTH CENTURY: VENICE

The other great centre for the production of bronzes was Padua. The importance of this Venetian centre in the history of the small bronze as an autonomous work of art is enormous; for it was the Venetians who gave the bronze the particular role it has played ever since, who discovered so many applications and practical uses for it, and who mass-produced it.

22 Desiderio da Firenze. *Electoral urn*. Museo Civico, Padua.

Because of this achievement, which reached its culmination in the generation of Il Riccio, the whole character of Paduan work differs from that of Florence.

To begin with, at any rate, contact between Padua and Florence was close, and each contributed to the development of the other. There was, of course, the presence in Padua of the Florentine Donatello, the real founder of the Paduan tradition of sculpture; he spent ten years working in his Santo yard, where both the *Gattemelata* and the huge complex for the San Antonio altar were cast. Equally important, from our point of view, were his two pupils, Bertoldo and Bellano. Both artists were equally happy working in either Florence or Padua. In 1483 Bertoldo was commissioned to make two panels for the Santo choir in Padua (subsequently made by Bellano) and he either worked on his *Bellerophon and Pegasus* at Padua, or had it sent there. Bellano followed Donatello to Florence in 1453, but in 1466 returned to Padua, where he and Bertoldo completed the pulpits which the master had left unfinished. The connection between Bertoldo and Bellano is now an established fact, and must be taken into consideration by anyone who attempts to assess the contributions made by the two artists to the development of the small bronze.

The best-known of Bellano's surviving works are the Paduan sculptures: marble bas-reliefs for a reliquary chest in the Santo (1469-1472) and, all belonging to the last ten years of his life (*c.* 1434-

1496/7), the bronze relief for the choir of the Santo, the De Castro tomb in Sta Maria dei Servi, and the tomb of Roccabonella in S. Francesco. Furthermore, he made small bronzes. His production of these must have been abundant and of great significance, though there are now only a very few pieces that can be confidently attributed to him: the *St Jerome* in the Louvre, the *David* formerly in the Foulc Collection in Paris and now in the Philadelphia Art Museum, and the *Hecate* in Berlin. The importance of his influence is evident in the anonymous Paduan statuettes produced before or during the first phase of Riccio's activity.

All of Bellano's bronzes are small, between 10 and 13in high. They are related to Bertoldo's work, but display certain important differences. Bertoldo's subjects are invariably profane and clearly intended for the humanist. Bellano's statuettes, on the other hand, are addressed to a wider audience with simpler tastes; their subjects are both sacred (*St Jerome, St David*), and profane (*Hecate* and the *Rape of Europa* in the Budapest Museum of Fine Arts – which I believe, as Planiscig was at one time inclined to do, to be by Bellano and not, as is generally supposed, by Riccio). And whereas Bertoldo succeeded in transforming humanist Classicism into a kind of rustic simplicity, Bellano possessed the greater gift for capturing an episode in all its everyday detail within the small compass of a statuette. This is apparent in his remarkable *St Jerome*: the saint has set down his book in

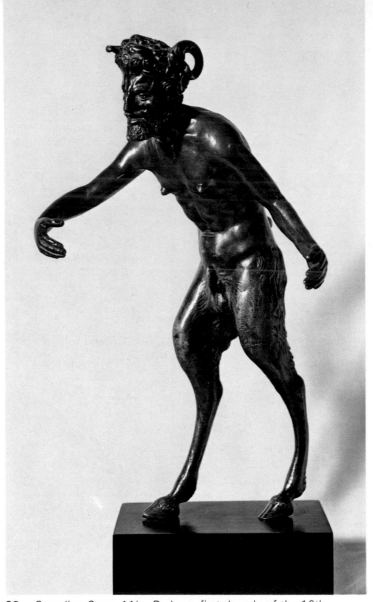

23 *Standing Satyr*. 11in. Paduan, first decade of the 16th
century. Victoria and Albert Museum, London.

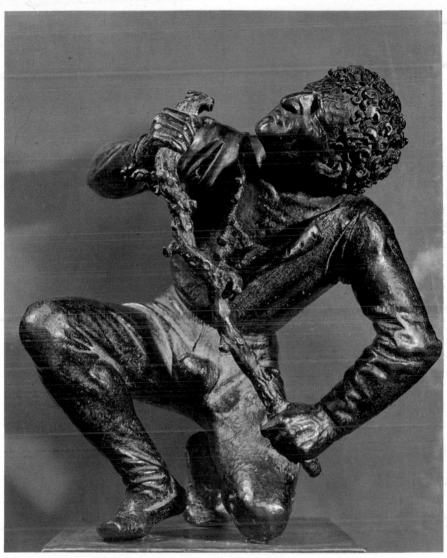

24 Peter Vischer the Elder. *Kneeling Man*. Bayerisches
Nationalmuseum, Munich.

23 *Standing Satyr.* 11in. Paduan, first decade of the 16th century. Victoria and Albert Museum, London. Brown varnish. Attributed by Planiscig to Desiderio da Firenze; but there are obvious discrepancies in style between this and the electoral urn in Padua, though there is no doubt that the piece is of Paduan origin.

24 Peter Vischer the Elder. *Kneeling man.* Bayerisches Nationalmuseum, Munich. Vischer the Elder (1460-1529) was the most important German Renaissance artist in bronze, and the head of a family of skilled foundrymen (Hermann Vischer the Younger, Peter Vischer the Younger). He came from Nuremburg, the home of the bronze statuette in Germany. Vischer had important contacts with the circle of Riccio, as can be seen from this statuette; its realism and feeling for the grotesque are, however, purely German.

25 Tullio Lombardo. *Female bust.* Galleria Estense, Modena. This exquisite statuette is by an artist who generally preferred to work in marble, in accordance with his wish to emulate Classical sculpture. Tullio was one of the best-known Lombard-Venetian Classical artists.

26 Alessandro Leopardi. *Rape of Europa.* 8½in. Museo Nazionale del Bargello, Florence. Black varnish and natural dark brown patina. Attributed first to Riccio and then to Bellano, this lovely little bronze has recently been traced to the circle of Alessandro Leopardi, who was an important exponent of Venetian Classicism in the early 16th century.

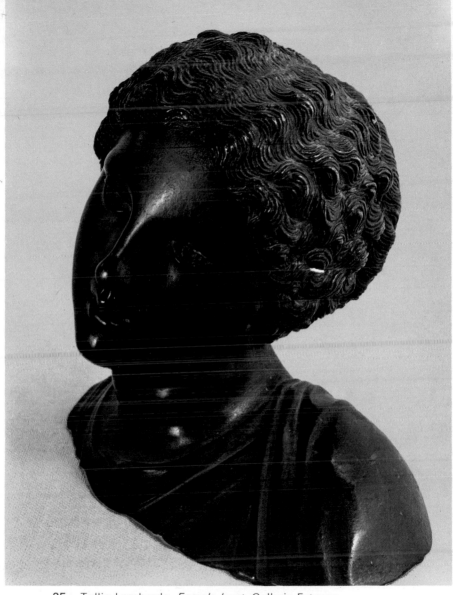

25 Tullio Lombardo. *Female bust*. Galleria Estense,
Modena.

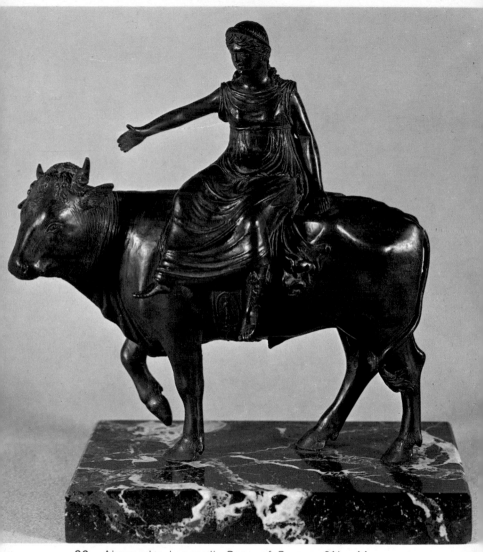

26 Alessandro Leopardi. *Rape of Europa*. 8½in. Museo
Nazionale del Bargello, Florence.

evident haste on the cushion at his feet; he is taking hold of the lion's paw, while his other hand is extended to remove the thorn. Bellano's *David* contains an element of symbolism but also expresses a simple feeling of wonder at a miraculous event. This is done by contrasts: the childlike David, the enormous broadsword and, below, Goliath's head with a great lump on the forehead.

Bellano's discovery of a narrative method greatly enlarged the possibilities of small bronzes. The same characteristics are visible in one of his larger masterpieces, the bronze reliefs for the Santo choir in Padua.

The Biblical stories are told by means of a series of designs such as Donatello might have used, but adapted to the requirements of popular narrative, the episodes combining narrative with moral instruction. The whole piece is utterly direct and sincere. Bellano's originality is also apparent in his style. The many small facets produced by his modelling crystallise the light on coloured surfaces which have been given a dark patina or coat of varnish. (Carpaccio, whose narrative manner is strikingly similar to Bellano's, achieved comparable effects in painting.) The use of varnish eventually became a regular feature of Venetian statuettes; with rare exceptions, the Tuscans preferred a natural patina, which corresponded better with their idea of form.

Another of Bellano's innovations was the portrayal of animals; this is credited to him because the 1695

inventory of the Paduan Mantoa Benavides Collection names him as the executant of a bas-relief representing a bull (plate 10). Comparison of this piece with Bellano's bronze reliefs of the Santo church supports the attribution. So far as can be ascertained today, Bellano (at the very least) discovered the use of animals as a subject in bas-reliefs, but Riccio was probably the first to use them for statuettes. This certainly agrees better with the artistic character of Riccio, since the creation of animal statuettes implies a move away from the taste for natural, anecdotal narrative so typical of Bellano and towards a more Classical and symbolical conception of animals – the Aesopian view of each species as a symbol of some human quality. There is nothing of this in Bellano's work; he confined himself to little scenes from everyday life, like the bull seen from behind – one episode among the many represented – in the *Sacrifice of Isaac* in the Santo choir. It therefore appears that all bronze statuettes of animals must be attributed to the influence of Riccio, including those (like the *Bull* and *Cow* in the Kunsthistorisches Museum, Vienna) whose cruder workmanship suggests an earlier date.

The *Grazing Bull* in the Ca d'Oro is not the only plaque of this kind of Bellano. Probably by him, though with a more accurate and polished finish, is the plaque of *Three Grazing Horses with their Grooms* (plate 9), which also belongs to the Mantoa Benevides Collection. There it is attributed to Titian Aspetti –

an attribution so absurd that it must surely have been made by mistake.

As already mentioned, Bellano was the dominating artistic personality in Padua during the final twenty years of the 15th century. This is proved by the existence of a large number of small bronzes imitating his works or crudely reflecting his style. Among the authenticated statuettes by Bellano which were copied with a few variations is the *David* formerly in the Foulc Collection and now in Philadelphia; a *David* in the Louvre and another in the Berlin Museum are derived from it. Another indication of his influence is the presence in Padua of other artists of note. The 'Master of the Dragon', for example, has strong affinities with Bellano (his facetted and unfinished modelling and angular poses), but he is more modern in that his subjects are Classical in a freer, more imaginative style and the faces of his figures have the Classical features later typical of Riccio. Bellano never worked in such a Classical manner, even in his last years, as is clear from the late reliefs on the Rocca-bonella tomb. For this reason, it is probably correct to see Bellano's hand in the magnificent *Mountain in Hell* (Victoria and Albert Museum), where the modelling is still more rugged and the forms more angular. The Master of the Dragon has been identified by Planiscig as Severo of Ravenna; the evidence is a dragon-shaped inkstand in R. Mayer's collection in Vienna which bears the signature 'O. SEVERI. RA.'

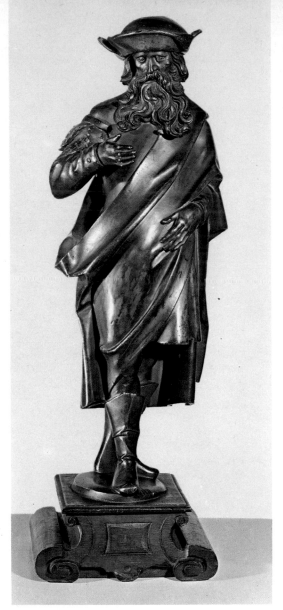

27 Herman Vischer the Elder. *St Sebaldo* (?). Kunsthis-
torisches Museum, Vienna.

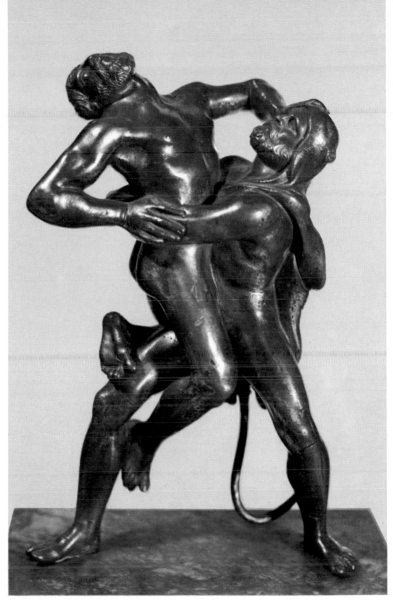

28 Peter Vischer the Elder and Peter Vischer the Younger. *Hercules and Antaeus*. Bayerisches Nationalmuseum, Munich.

27 Herman Vischer the Elder. *St Sebaldo* (?). Kunsthistorisches Museum, Vienna. Attributed for a time to Peter Vischer the Elder, but now believed to be by his father, Herman (died 1487). The Burgundian training of the artist is evident.

28 Peter Vischer the Elder and Peter Vischer the Younger. *Hercules and Antaeus*. Bayerisches Nazionalmuseum, Munich. After the St Sebaldo altar in Nuremberg, Peter Vischer the Elder worked in close collaboration with his two sons, Herman and Peter. Peter the Younger (1487-1529) followed Italian Renaissance developments, especially those of northern Italy, very closely. This group, for example, recalls the small bronzes of Antico, though realistic and popular traits typical of German art remain.

29 Pier Jacopo Alari Bonacolsi, known as Antico. *Apollo*. 16in. Museo della Ca d'Oro, Venice, Dark patina, partly fire gilded; eyes damascened with silver. This statuette, a copy of the famous *Apollo Belvedere,* is perhaps Antico's masterpiece.

30 Pier Jacopo Alari Bonacolsi, known as Antico. *Meleager.* 12in. Kunsthistorisches Museum, Vienna. Dark patina, partly gilded; eyes damascened with silver. This statuette is a copy of a Classical sculpture, known from an example in the Palazzo Pitti in Florence; but the rare skill with which it is made gives it an independent value. These copies of Classical models were specially commissioned from the artist by the famous Isabella d'Este.

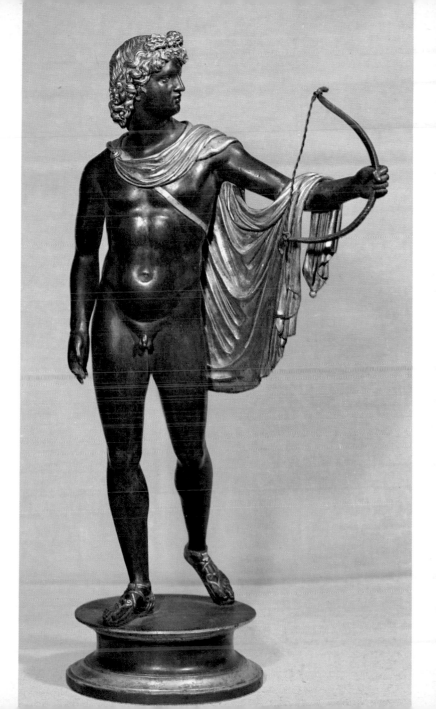

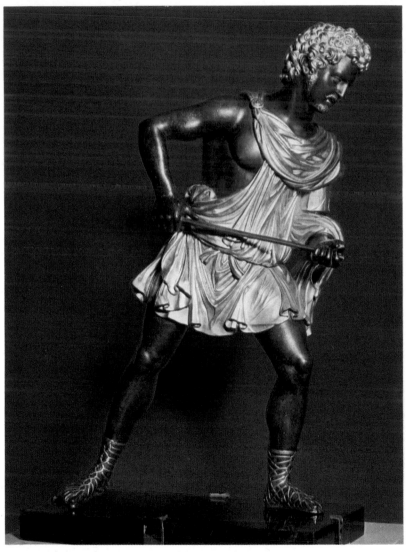

30 Pier Jacopo Alari Bonacolsi, known as Antico.
Meleager. 12in. Kunsthistorisches Museum, Vienna.

The dragon was the characteristic feature of this artist's work, examples being *Pluto with a Dragon* (plate 21) in the Bargello, Florence and another *Pluto*, slightly different and rather smaller, in the Frick Collection in New York.

When Pomponio Gaurico wrote his *De Sculptura* (1504), only four or five years after Bellano's death, profound changes had already taken place in Paduan art. Gaurico inevitably sided with the new generation, extolling Riccio and denigrating Bellano as 'ineptus artifex'. It was in fact Andrea Briosco, called Riccio (1470/75-*c*.1532), who effected the change from the experimental popular naturalism of Bellano to a cultivated Classical naturalism. This took place during the years around the turn of the century, and was symptomatic of the spirit of the times; for there was everywhere a tremendous revival of the Classical spirit. In northern Italy it was a Classicism of a very special kind, literary and humanistic, which sought to recreate Classical Antiquity in all its aspects, striving for a formal purity characteristic of Greek art; such an attitude, unyielding and impassioned, resembles that of the Romans towards Greek art in the time of Augustus.

In Venice, those principally responsible for the new artistic vision in the field of monumental sculpture were the brothers Tullio and Antonio Lombardo, whom Pomponio Gaurico regarded as the equals of Riccio. Riccio's Classicism is probably derived from

these two sculptors, who were some twenty years his senior; they are said to have been working in 1575, about the time when Riccio was born. But comparison with the formal purity of the Lombardo brothers makes it clear that Riccio drew to a significant extent on the Paduan tradition of naturalism created by Bellano. This is apparent chiefly in his small bronzes; in larger works (like the two bas-reliefs of the stories of Judith and David in the choir of the Santo church, and those on the Torre tomb) Riccio followed the prevailing style of refined Classicism. He was the first artist to make this distinction, which was of enormous importance. Small bronzes acquired qualities of lively narrative and expressive vigour which they retained even when monumental sculpture deteriorated, as happened towards the middle of the 16th century.

We shall now examine the principal stages of Riccio's artistic activity, which was tremendous; innumerable small bronzes – attributed or authenticated – bear his name. Since there has been no detailed account of this large body of work, only one or two authenticated pieces will be discussed here. For the rest, it is impossible to better Landais' statement that, in order to recognise Riccio's authenticated small bronzes, there is one sure criterion: that of quality, 'car c'est bien à un artiste de premier ordre que nous avons affaire'. There is a very large number of more or less good copies of Riccio's works (the

practice was already well-established in Padua in Bellano's time), and a qualitative standard must be applied in order to distinguish between imitations and the products of his workshop.

Another method of authenticating and dating Riccio's statuettes is to compare them with his major, authenticated works, which are fortunately quite numerous. The principal ones, marking the different stages of his development, are as follows. First of all, three statues of Riccio's youth: *Faith, Hope* and *Charity* on the Roccabonella tomb. These, left unfinished at the time of Bellano's death (1496/97), exemplify Riccio's early style. The design is typical of Bellano, its execution depending especially on line, created with hard rapid strokes of the graver. Later works are the two reliefs of the *Story of Judith* and the *Story of David* executed between 1506 and 1507 for the choir of the Santo Church. Three terracotta statues of *St Henry, St Agnes* and *St Jerome* (Church of S. Cassiano, Padua) also belong to this period. These works reveal a more mature Classical style but one which still displays traits derived from his apprenticeship to Bellano − for example the use of gravers for rapid definition and emphasis in depicting drapery, hair or facial features. In the same period he produced a large number of small bronzes, forcefully and vigorously modelled. The most authenticated are: the *Horseman* (Salting Collection) in the Victoria and Albert Museum; the *Arion* in the Louvre; the

Dancing Satyr in the Lederer Collection in Vienna; and the *Satyr Crowned with Vine-leaves Holding a Shell* in the Bargello, Florence.

The great Easter candelabrum for the Santo Church, completed between 1507 and 1515, is possibly Riccio's most famous work, and exemplifies his style at its greatest maturity and elaboration. Here, juxtaposed in an unprecedented manner, are the pure, Classical style of the reliefs and fantastic, ebullient and inspired Classical and mythological beings such as sphinxes, satyrs and cupids. This work – executed for the majestic church of Il Santo – represents a triumph for the secular spirit, as does Riccio's astonishing Classical design for the tomb of Marco Antonio Della Torre in S. Fermo, Verona, made soon after the candelabrum. In these bas-reliefs, now in the Louvre, Riccio describes the day-to-day life of Verona, idealised and transposed into the costumes and attitudes of ancient Greece.

Riccio's most characteristic statuettes were made at about the same time as the Easter candelabrum, from which many of them were derived. Pieces which certainly belong to this particular style are: the *Girl with Goose* (Kunsthistorisches Museum, Vienna); the *Abundance* (plate 20); the *Male and Female Satyrs* (plate 15); the *Drinking Satyr* (Kunsthistorisches Museum, Vienna); and the *Seated Satyr* (plate 19), of which there is a very fine replica in the Museo di Palazzo Venezia in Rome. I would put the *Herdsman*

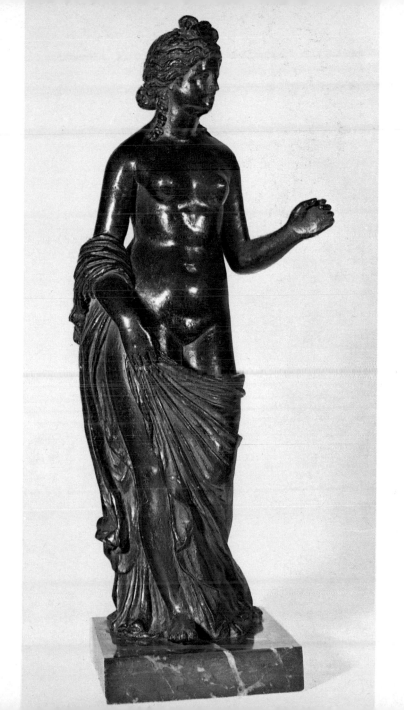

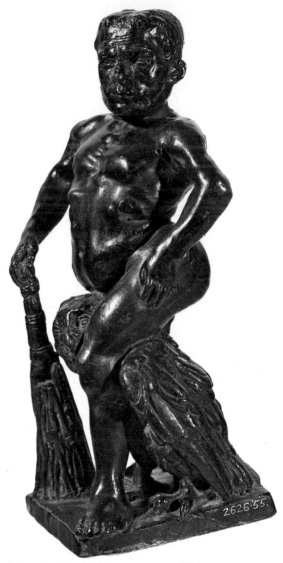

32 Niccolo Tribolo (attributed). *Aesop*. 13in. Victoria and Albert Museum, London.

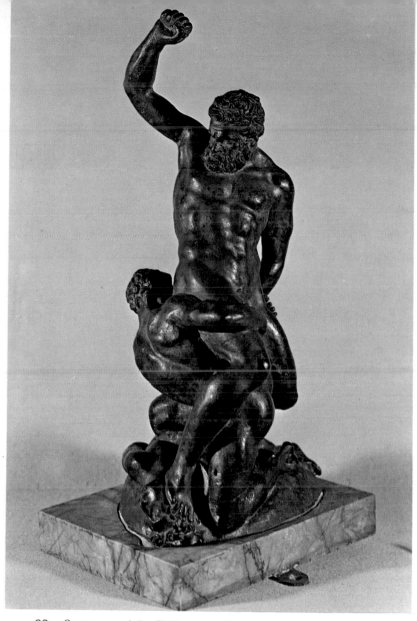

33 *Samson and the Philistine.* 14in. Tuscan. *c.* 1540
Museo Nazionale del Bargello, Florence.

31 Pier Jacopo Alari Bonacolsi, known as Antico. *Venus.* 10½in. Museo di Capodimonte, Naples. This is a trial casting. There is another version, perfectly finished and gilded, in the Kunsthistorisches Museum, Vienna. They are copies of a Classical statue called *Venus Felix,* known in various copies from Roman times.

32 Niccolo Tribolo (attributed). *Aesop.* 13in. Victoria and Albert Museum, London. Dark patina. A beautiful work, but difficult to attribute. Pope-Hennessy has ascribed it to Tribolo, but there seems no doubt that it has a more Nordic taste for the grotesque, and is therefore of a later date.

33 *Samson and the Philistine.* 14in. Tuscan, *c.*1540. Museo Nazionale del Bargello, Florence. Black varnish and natural greenish patina; attributed for a time to Daniele da Volterra. This statuette derives from a lost model by Michelangelo which, about halfway through the century, achieved sudden fame among the Mannerists. It was reproduced in many small bronzes by various artists. This one has been attributed to Tribolo because of its sincerity and ample modelling.

34 Baccio Bandinelli. *Cleopatra.* 12in. Museo di Capodimonte, Naples. A workshop replica of the very beautiful and faultlessly finished statuette in the Bargello.

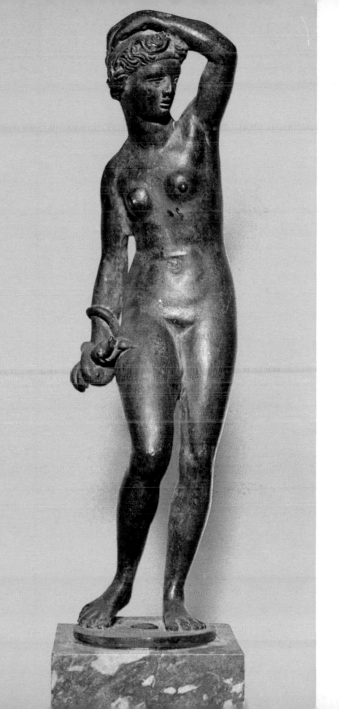

with Goat (plate 12) a little later, about the time of the Della Torre tomb in Verona. Although it is generally held to be an early work, it is in the smoother, more Classical style which distinguishes the Veronese works from the Santo candelabrum, on which the play of light over variations in the modelling gives a dappled, vibrant effect.

The few statuettes we have discussed indicate the wealth of themes treated in this new art. Some of the bronzes were purely ornamental; others were salt-cellars, lamp-holders and inkstands. As Pope-Hennessy has observed, the subjects belong to a world halfway between the human and the animal (like the *Male and Female Satyrs*) or the human and the mythological (like the *Abundance* or the *Seated Pan* in plate 14). What is especially striking is the profoundly human character given to these almost subterranean figures, a character manifested in extraordinary eloquence of gesture and expression – the features of the *Seated Satyr* contorted by suffering, the astonished curiosity of the *Seated Pan,* the violent desire on the faces of the *Male and Female Satyrs*. In stylistic terms, this new feeling of humanity is expressed with an ease of touch and modelling which floods the surfaces with a light resembling sunlight filtered through leafy branches in a grove; an extremely appropriate effect for these mythical beings.

Riccio's other 'conceits' include polyps, crabs, lizards, shells, frogs, eagle's claws used as supports,

and a bucranium (ox-skull) for use as an oil-lamp. They too exemplify a vision compounded of realism and antiquarianism, fantasy and myth. In these astonishing objects, in strong contrast with the dignity of his monumental pieces, Riccio – like Piero di Cosimo in Florence – expresses the disquiet of the 16th-century artist, and a premonition of the future crisis of Mannerism. Although his style had certain archaic characteristics and is closely related to that of a wholly 15th-century artist like Tullio Lombardo, Riccio's later work may be regarded as having opened the new chapter of 16th-century art.

The Lombardo brothers also worked in bronze, though only as a side-line. The only authenticated statuettes which have survived are two exquisite female busts (Galleria Estense, Modena) by Tullio (c.1455-1532); one of these is reproduced in plate 25. They agree very well with his marble heads, worked with the neatness of a cameo; in bronze he achieved effects that were subtler and more luminous. A few small bronzes have been attributed to Antonio Lombardo (c.1458-1516?) by Bode, in particular a *St John the Baptist* (Ashmolean Museum, Oxford), but it is too archaic in style; compared with that of his brother Tullio, Antonio's outlook was wide and flexible, transcending the precise definition that characterised the art of the 15th century. The altar of the Zen Chapel in St Mark's, made during the first decade of the 16th century, is stylistically as well as

chronologically the first 16th-century Venetian sculpture.

Riccio's influence was tremendous in both Padua and Venice. In Venice, however, the combined influence of Riccio and the Lombardo brothers affected artists who remained in most respects old-fashioned. Such was the case with 'the Master of the Barbarigo Altar', so called on account of a series of small bronzes completed in 1515 for the altar of the Barbarigo in the Carità church in Venice, and now in the Ca d'Oro; and with Alessandro Leopardi. Leopardi (?-1522/3) was a famous bronze foundryman. He completed the casting of Verrocchio's *Bartolomeo Colleoni* and made the two bronze sockets for flagpoles outside St Mark's Church; these are surrounded with a frieze of marine deities of a quite astonishing quality. I am inclined to attribute the enchanting *Rape of Europa* (plate 26) to Leopardi rather than (as is usual) to Riccio.

The Paduan Francesco da Sant'Agata remained in the ambit of Riccio's school, but struck an almost entirely 16th-century note. His signature, 'Opus Francisci Aurifici', is carved on the boxwood statuette *Hercules* (Wallace Collection, London) seen by Bernadino Scardeone in 1560, at the house of Marcantonio Massimo in Padua, as the work of 'Francisco a Santa Agatha, Paduan silversmith'. He has been identified with the maker of a group of small bronzes which includes a *Hercules* (Ashmolean

Museum, Oxford), a *Niobe* (Kaiser Friedrich Museum, Berlin), another *Niobe* in the Wallace Collection, and a *Horn Blower* in the Louvre. This identification has recently been widely questioned, however.

One of Riccio's Paduan pupils was Desiderio da Firenze (mentioned between 1532 and 1545), but his works are in a much later manner which suggests that he very early came under the influence of Jacopo Sansovino, who arrived in Venice soon after 1527. In 1533 Desiderio made an electoral urn (plate 22) now in the Museo Civico at Padua. Planiscig also attributes a *Standing Satyr* (Victoria and Albert Museum), a *Satyr Drinking from a Goblet* and a *Satyr Leaning Against a Tree* (Kunsthistorisches Museum, Vienna) to him; but these works, which are of recent attribution, have nothing in common with the Paduan urn.

THE FIFTEENTH CENTURY: NORTHERN ITALY

The small bronzes of northern Italy – apart from those of Venice – are little known, though a great deal of bronze work was done in Lombardy and Emilia. This was strongly influenced by Paduan work; first, because it was from Padua that the art of the Renaissance and of Donatello was disseminated (it can be assumed that nearly all northern Italian sculp-

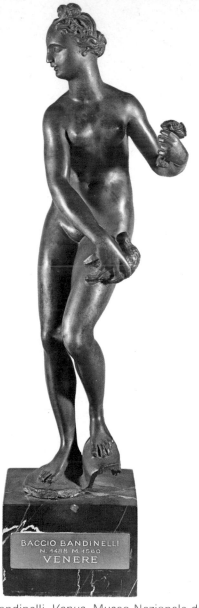

35 Baccio Bandinelli. *Venus.* Museo Nazionale del
Bargello, Florence.
36 Benvenuto Cellini. *Danae.* Piazza della Signoria, Loggia
dei Lanzi, Florence.

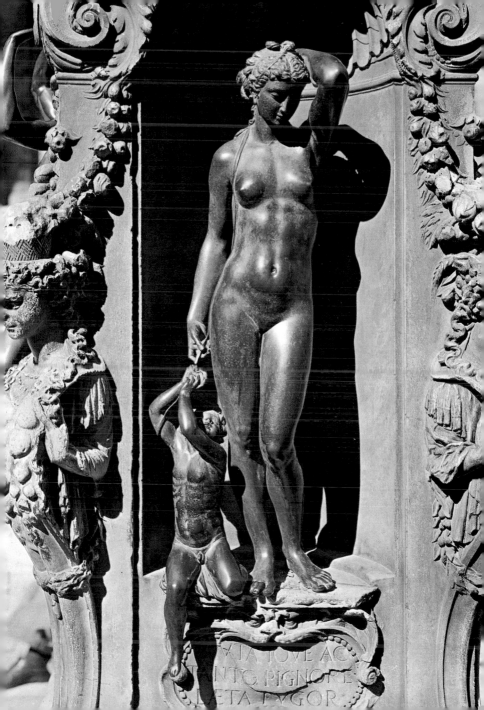

35 Baccio Bandinelli. *Venus.* Museo Nazionale del Bargello, Florence. The Bargello owns a group of beautiful statuettes by Bandinelli. They are the most successful of the artist's works, of a perfection almost impossible to sustain in the hard and prolonged labour entailed by large-scale sculpture. The workmanship of Bandinelli's statuettes is characterised by perfect casting.

36 Benvenuto Cellini. *Danae.* Piazza della Signoria, Loggia dei Lanzi, Florence. Since there is no unquestionably authenticated bronze statuette by Cellini (the Perseus model was not made as a work of art in its own right), we show one of the small bronze figures at the base of the Perseus. They have all the characteristics of a statuette: a self-contained, harmonious rhythm and extreme refinement of workmanship.

37 Benvenuto Cellini. *Mercury.* Piazza della Signoria, Loggia dei Lanzi, Florence. The small bronze figures in the base of the Perseus must be regarded as masterpieces of Italian Mannerism: they adhere to its most refined canons — the elongation of the figure and the complex, twisted arrangement of the limbs.

37 Benvenuto Cellini. *Mercury.* Piazza della Signoria. Loggia dei Lanzi, Florence.

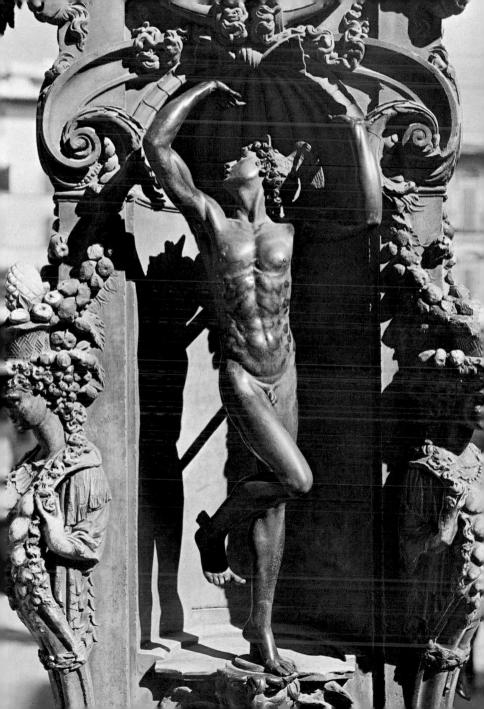

tors, particularly sculptors in bronze, were trained there); secondly, because the genius of Riccio had made Padua the meeting-place of Lombard and Venetian Classicism. The great bronzes of Ferrara cathedral derive from Donatello's work in Padua; they were executed by the Florentine Niccolo Baroncelli, a naturalised citizen of Ferrara. Derived from Padua, and from Bellano in particular, are the four great bronze figures of the *Evangelists* executed by Filippo da Gonzate for Parma Cathedral in 1508. It was in Donatello's Paduan workshop that Agostino dei Fondati was trained; this Paduan artist moulded the terracotta frieze in S. Satiro, Milan, and must also have worked in bronze, as his name implies. And there must have been connections between the school of Riccio and the anonymous artist who made the doors for the chain store of St Peter's (now in S. Pietro in Vincoli, Rome) and a bronze box known from various copies (one in the Bargello, Florence). This artist has been identified with the famous Milanese goldsmith Caradosso.

The centre at Mantua worked in the tradition of Lombard-Venetian Classicism but made an individual contribution. A very fine artist, Pier Jacopo Alari Bonacolsi (*c.* 1460-1528) worked at the highly cultivated court of Isabella d'Este; he signed a series of medals 'Antico'. Antico made a number of bronze statuettes, in intention copies of famous Classical works, which were in fact works of art in their own

right. In 1497, for example, he was sent to Rome to arrange the acquisition of antique marbles and make reproductions of works it was impossible to acquire. Antico's greatest works are: *Apollo* (plate 29) which is a copy of the *Apollo Belvedere; Venus Felix* (Kunsthistorisches Museum, Vienna), which derives from the marble statue in the Vatican Museum; *Love Drawing a Bow* (Bargello, Florence); and *Hercules* and *Hercules and Cacus* (both in the Kunsthistorisches Museum, Vienna). *Hercules and Cacus* is a copy, cast by Gian Marco Cavalli, of the marble Classical group now in the courtyard of the Pitti Palace; it displays some slight but significant differences from the Classical original.

Technical points by which this group (every piece between about 12in and 16in high) is distinguished include perfect casting and finishing, and the use of gilt for clothing and sometimes hair, enabling Antico to display the skill of a goldsmith and his taste for expensive decoration. It must be remembered that his finishing and gilding was intended to produce a more faithful reconstruction of the Classical Greek original. It is because of this that Antico belongs to the great Lombard-Venetian Classical movement which took the form of a neo-Greek revival. He is included in this chapter because of his participation in that movement, although his figures have a fullness of modelling and an easy breadth of gesture which was characteristic of the 16th century.

THE SIXTEENTH CENTURY: FLORENCE

At the beginning of the 16th century, there were great artistic developments which in Florence marked the beginning of a new era in art. Leonardo, Michelangelo and Raphael, despite the differences between their manners, introduced a new style in figurative art. Leonardo rendered the human figure in conjunction with its surroundings, distinguishing it from them by variations in light and shade. He chose bronze as the most suitable and expressive material for his sculptures: the equestrian statue in Milan (destroyed by the French) and the statue of Giangiacomo Trivulzio, which he left unfinished. No other works in bronze are definitely known to be by Leonardo; the three equestrian statues attributed to him – *Soldier on Horseback* (Budapest Museum), the statuette in the Metropolitan Museum, New York, and the *Winged Horse* (Jeanneret Collection, London) – are not in fact his work. The *Winged Horse* is almost certainly a fake of recent date, as Santangelo has argued; this is suggested by its Rodinesque modelling and its soft patina, done with lamp-black, which is altogether modern.

Leonardo's preference for bronze aroused great interest in the material, and it was his followers who made the few Florentine bronzes – small and large – of the first ten years of the 16th century. One of these was the great Florentine sculptor, Giovan Francesco

Rustici, whose two principal works were a group of full-size figures, *The Baptist's Sermon*, on the north door of the Baptistery at Florence, and the small bronze of *Mercury*, designed for a fountain at the Palazzo Medici, and now in a private collection in London. These are at present the only authenticated bronzes by Rustici; others have been attributed to him at various times, but are definitely not by him. The same inner needs are apparent in his work as in Donatello's; both were driven to work in bronze, whose extreme pliability could give form to their spiritual unrest.

Another bronze statuette of the early part of the 16th century, *St John the Baptist*, was created by an artist connected with but not belonging to Rustici's circle: Francesco da Sangallo. It was a cast of one of his marble sculptures for the baptismal font of Sta Maria delle Carceri, Prato.

Michelangelo's influence was in a totally different direction from Leonardo's. It was his unshakeable conviction that sculpture should, 'by raising up', display an ideal and universal form for ever fixed in stone. This excluded the use of bronze not only because it was sculpture by 'setting down', but also because the material used to create the form had already been worked. Michelangelo worked in bronze only once – in 1506, when he made the statue of Julius II for the façade of S. Petronio in Bologna. He cannot therefore be said to have had any influence on

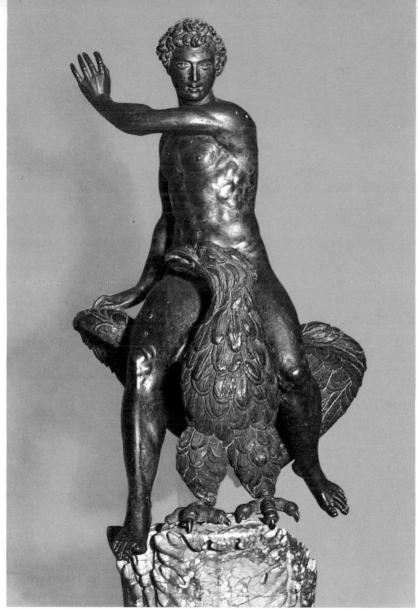

38 *Ganymede*. 24in. Tuscan, mid 16th century. Museo Nazionale del Bargello, Florence.

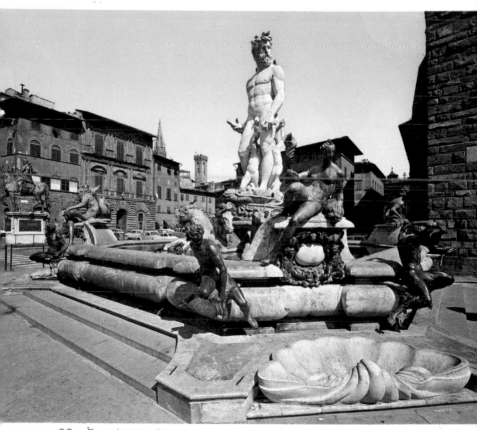

39 Bartolomeo Ammannati *Neptune Fountain*. Piazza della Signoria, Florence.

38 *Ganymede.* 24in. Tuscan, mid 16th century. Museo Nazionale del Bargello, Florence. Brown patina. Variously attributed to Cellini and Tribolo, this magnificent bronze has economical, slightly stylised modelling that does not agree with the style of either artist. The skill with which it is executed indicates considerable experience of work on a small scale.

39 Bartolomeo Ammannati. *Neptune Fountain.* Piazza della Signoria, Florence. This monumental, sumptuous work marks the climax of the application on a large scale of iconographic motifs (satyrs, etc.) which in design and style had been elaborated in small bronze work.

40 Bartolomeo Ammannati. Detail of the *Neptune Fountain.* Piazza della Signoria, Florence.

41 Leone Leoni. *Seated Warrior.* $3\frac{1}{2}$in. Galleria Estense, Modena. Although Leoni was a famous medallist and worked mainly in bronze, there are very few small bronzes by him; and they are generally inferior in quality to his masterpieces on a larger scale.

40 Bartolomeo Ammannati. Detail of Neptune Fountain. Piazza della Signoria, Florence.

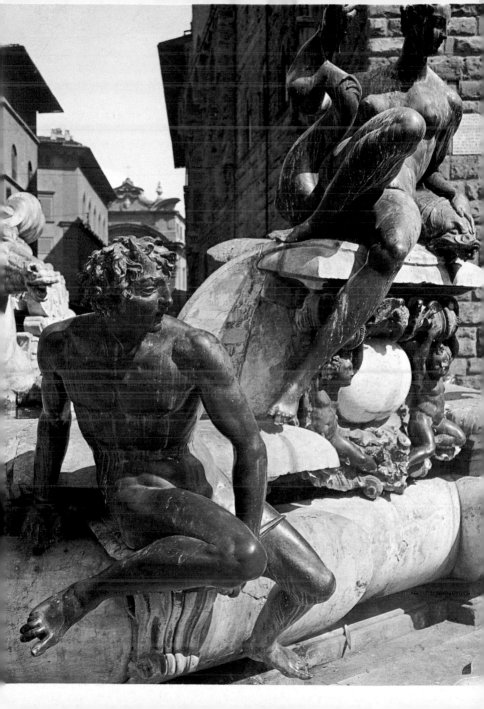

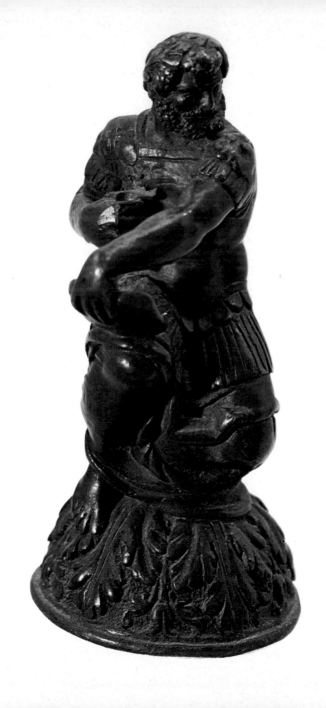

the small bronzes produced in Florence during the first ten years of the 16th century.

This production was, however, affected in a special way by the Classical movement which was led in sculpture by Andrea and Jacopo Sansovino and – in a less direct sense – by Raphael. This ensured the continuance of the great Classical tradition of bronze statuettes, of which large numbers of Antique examples were beginning to come to light. An important event in this connection was the competition for the best bronze copy of the *Laocoon*. Raphael presided over it, and one of the participants was Jacopo Sansovino, who was to become the creator of the Classical bronze statuette of the 16th century. Yet it does not appear that Classicism inspired any small bronzes in central Italy before about 1530; for it was in Venice that Sansovino executed all the small bronzes for which he became famous. The Classical *Pan* (Bargello, Florence) lately rediscovered by Holderbaum was executed in Florence in about 1540 by Tribolo; but it clearly derives from the Paduan circle of Riccio, with which Tribolo had become acquainted when he and Cellini had made a journey to Venice in 1536. Even quite late in the 16th century, northern Italy was evidently the guiding centre so far as bronze statuettes were concerned; in central Italy the development of the art had been retarded by Mannerist preoccupation with form and the influence of Michelangelo.

In his *Pan*, which is one of the most beautiful

41 Leone Leoni. *Seated Warrior*. 3½in. Galleria Estense, Modena.

bronze statuettes made in 16th-century Florence, Tribolo succeeded in rendering face and gesture expressively, combining it with vigour of form and passionate and vibrant modelling. The whole is imbued with a humanity characteristic of a deeply-felt Classicism. In view of these facts, the attribution to Tribolo of the *Aesop* (plate 32) in the Victoria and Albert Museum, London seems dubious. Despite a convincing similarity in style between the two works, the *Aesop* displays a taste for the deformed and the grotesque that seems quite out of keeping with the warmth and sincerity of Tribolo's art. The difference between this and Tribolo's signed works becomes even more apparent when we look at *Dwarf on a Shell* (Louvre, Paris), which is almost certainly by the same hand as *Aesop*. Too little is still known about 16th-century Italian bronzes for us to be confident about any attributions, however ingenious or scholarly; much remains obscure even in the field of monumental sculpture. If it were ever proved that the *Aesop* was Tribolo's work, it would raise many difficult problems about the relationship between Florentine Classicism and international Mannerism.

No small bronze can with certainty be attributed to Pierino da Vinci (1521-1554), who was Tribolo's pupil and collaborator during the last ten years of his activity (1540-1550). The *Fury* formerly in the Auspitz Collection in Vienna (now in the Boymans Museum, Rotterdam), has been attributed to Pierino because

it resembles the bas-relief *Death of Count Ugolino* (Bargello, Florence) in subject and fluidity of line, and it displays many other points of similarity with Pierino's work. Nonetheless, the over-emphatic use of light and shade effects and the unequivocal adoption of first-generation Mannerist features seems to prove that the *Fury* is of a later date. It is just because they are so clearly a part of that great artistic movement that the many statuettes attributed to Pierino da Vinci by Planiscig cannot be accepted as such. These include: *Centaur with Lapithaean Woman* (Kaiser Friedrich Museum, Berlin), *Lucifer* (Berlin, formerly J. Simon Collection), *Mercury and Argus* (Louvre, Paris), *Fury* (Victoria and Albert Museum, London), *Hercules* (Figdor Collection, Vienna), and an inkstand with *Perseus and Medusa* (Rothschild Collection, Vienna).

The Florentine bronze statuette, whose history is especially glorious from the middle of the 16th century, does show a tendency towards Mannerism. This occurred when the first, innovatory stage began to give way to a demand for a new rule in the figurative arts. To this stage of Mannerism, which was academic in the best sense of the word, belongs Bacio Bandinelli (1488-1561). Besides being a famous sculptor – the rival of Michelangelo at the court of the Medici – he was the creator of the most beautiful Florentine bronze statuettes before Giambologna. The most important are a group of five statuettes now in the Bargello,

Florence; they are *Hercules, Cleopatra, Jason, Leda* and *Venus with a Dove* (plate 35), which has the name of the artist, 'Baccius Bandinellus', inscribed on the shell at its base. There is another example of the *Cleopatra* (plate 34), but without finishing, in the Museo di Capodimonte at Naples. The statuettes were executed for the Medici at various intervals during the last twenty years of the artist's life (after 1540), when he was working in Florence.

Bandinelli's bronzes are widely regarded as being of especial value, because of their unsurpassed formal beauty and because so much study was devoted to creating them. (There is what must have been one of the final drawings for the *Jason* in the Gabinetto dei Disegni e Stampe, Florence; and doubtless a great deal of preparatory drawing was done for the other statuettes.) Unlike Tribolo's *Pan*, a playful subject intended simply for decoration, these statuettes represent highly serious formal conceptions which have been reduced to a small scale without losing anything of their monumental quality. Two elements in Bandinelli's culture combined to produce this result: a worship of form as something absolute and universal, which he derived from Michelangelo, and an untiring study of Classical sculpture.

The technical perfection of these models is apparent in their faultless casting, exquisite patina and finishing, balanced rhythmic design and broad and graceful modelling. The basic characteristics of Bandinelli's

42 Giambologna. *Astronomy*. Kunsthistorisches Museum, Vienna.

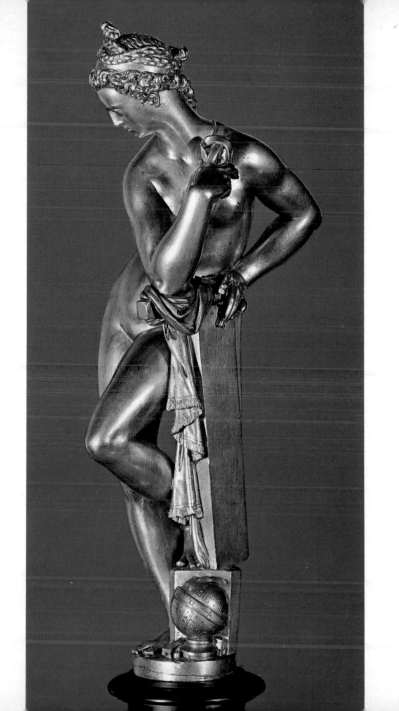

42 Giambologna. *Astronomy.* Kunsthistorisches Museum, Vienna. Signed; belongs to the mature period, stylistically close to the *Venus of the Grotticella* (*c.*1573). This statuette, with its fluent contours and vibrant use of light and shade, is one of the masterpieces of late Mannerism.

43 Giambologna. *Morgantes on a Dragon.* 14½in. Museo Nazionale del Bargello, Florence. For a time attributed to Valerio Cioli but recognised by Keutner (1956) as Giambologna's: it was identified from the ornament on the fountain in the hanging garden (created between 1583 and 1585) on the roof of the Loggia dei Lanzi. The blend of fantasy and realism reveal the Flemish origin of the artist.

44 Giambologna. *Christ of the Column.* 11½in. Museo Nazionale del Bargello, Florence. One of the loveliest of Giambologna's religious statuettes. Responding to the Counter-Reformation, Giambologna made the first Florentine statuettes intended for use in private devotion. The rounded elegance and boldness of this figure are late Mannerist characteristics.

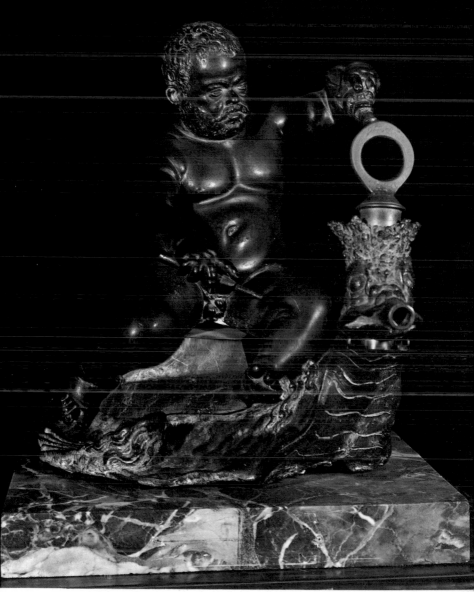

43 Giambologna. *Morgantes on a Dragon*. 14½in. Museo
Nazionale del Bargello, Florence.

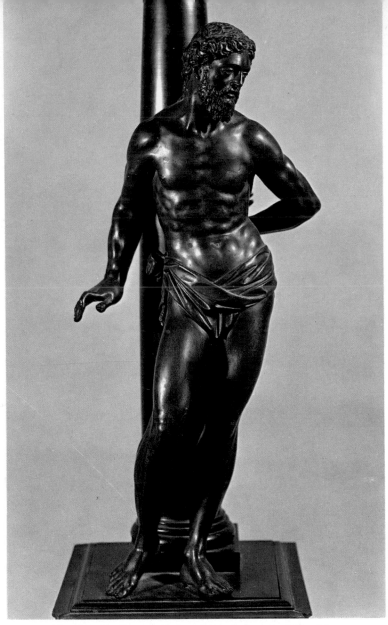

44 Giambologna. *Christ of the Column*. 11½in. Museo Nazionale del Bargello, Florence.

style make it clear that he was inclined to prefer marble, which was better suited to his ideals of formal perfection. For Bandinelli, indeed, the production of bronze statuettes was a secondary activity, but not necessarily a spasmodic one. I, at any rate, believe that he worked steadily on small bronzes from his boyhood, having been trained by his father, Michelangelo di Viviano, who was a famous goldsmith and an undisputed master in his own field. There is an indication that Bandinelli worked in this field in Rome; this is to be found in the engraving of *The Academy of Baccio Bandinelli* executed after his drawing by Agostino Veneziano.

On the other hand, bronze was the favourite material of the Tuscan Mannerist sculptors. It enabled them to express on a large scale their ideals of an artificial and rhythmical beauty composed of 'licence' and 'rules'; 'licence' meant elongated shapes, the wilful alteration of bodily proportions, intricate movements in strained poses which, however, remained harmonious and flowering as a result of obedience to 'rules' – the Classical rules of balance and compensation. Marble did not allow the Mannerist artist the freedom he could enjoy in bronze. Thus Cellini (1500-1571), one of the most representative sculptors of later Mannerism, worked almost exclusively in bronze, a material suited to his skill as a goldsmith. His most monumental works are of bronze; the *Nymph* at Fontainebleau, *Perseus* (Piazza

della Signoria, Florence), and *Cosimo I* (Bargello, Florence). Yet almost no independent bronze statuettes by Cellini have survived. (The small-scale model of *Perseus* – about 28in – cannot of course be so described.) None of the small bronzes attributed to him displays the extreme elegance of form, the subtlety and decorative imagination of the polished artist who modelled the bronze figures in the small niches at the base of the *Perseus*. I refer in particular to the *Venus* (New York, formerly in the Morgan Collection), and the *Venus and Cupid* (Lederer Collection, Vienna). Only the *Ganymede* (Bargello, Florence), one of the most beautiful Florentine bronze statuettes, matches the quality of Cellini's works; and its characteristics are not those of his style. What *Ganymede* does have is marked dignity of form, simplicity of modelling and monumental stability – none of which are to be found in Cellini's work.

A conviction that Tuscan sculptors were mainly interested in large-scale work is supported by the fact that there are no bronze statuettes by Bartolomeo Ammannati (1511-1592), the other great master of mid 16th-century Florentine Mannerism. Ammannati's masterpiece, the *Neptune* in the Piazza della Signoria, Florence, was made of bronze; but the small bronzes that have been attributed to him have not withstood the scrutiny of critics, and have been credited to other artists. The *Hercules* and the

Omphale in the Museo Civico, Padua, are recognised as the work of Francesco Segala; the very beautiful *Hercules Gradenigo* is difficult to place but is certainly not Tuscan. Ammannati performed the astonishing and difficult feat of reconciling in bronze the lifelike forms of Michelangelo and the flowing forms of Sansovino; his work combines elegance and sophistication with a natural expressiveness, giving new life and significance to the world of satyrs and nymphs which Riccio had discovered half a century earlier. It should also be mentioned that Ammannati worked in Venetia for about ten years, first in Sansovino's workshop in Venice, then as an independent artist in Padua – a striking indication of the persistence of northern Italian influence.

In the year in which Ammannati executed the *Fountain of Neptune* (1565) a young artist who had only recently arrived from Flanders was already making his reputation. Giambologna (1529-1608), a native of Douai, was destined to play a role of prime importance in Florence during the last thirty years of the 16th century, as the leading artists of the previous generation – Bandinelli, Ammannati, Cellini – began to disappear. The influence of Giambologna as a sculptor and creator of bronze statuettes was felt in many different and somewhat complex ways. For variety of subject, quantity and quality, his statuettes were outstanding in Florence, recalling (without, however, equalling) the achievement of Riccio. This

45 Giambologna. *Mercury*. 23½in. Museo di Capodimonte, Naples.

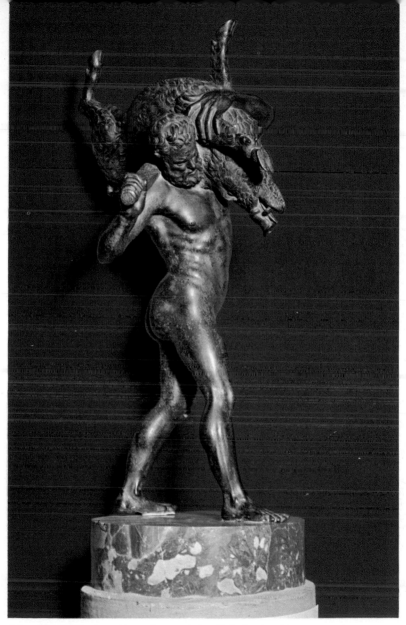

46 Giambologna. *Hercules and the Calydonian Boar.*
17½in. Museo di Capodimonte, Naples.

45 Giambologna. *Mercury.* 23½in. Museo di Capodimonte, Naples. Sent to Ottavio Farnese soon after 1579. The artist made use of this design several times. It can be seen in bronze in life size (1564) at the Bargello, and on a small scale (1565) in the Kunsthistorisches Museum, Vienna. This statuette is an astonishing example of the Mannerist virtuosity of the period.

46 Giambologna. *Hercules and the Calydonian Boar.* 17½ in. Museo di Capodimonte, Naples. Part of the series of four Labours of Hercules of which the protagonists are animals. The best examples are in the Bargello, Florence; there are a great many, predominantly workshop replicas, though of excellent workmanship. Giambologna's foundrymen were invariably highly skilled.

47 Adrian de Vries. *Runner.* 7in. Kunstmuseum, *Cologne.* De Vries was the most gifted and refined of Giambologna's Flemish pupils. He completed his training in Italy, and Italian influence — though transmitted by the northerner Giambologna — was decisive in his art: it expresses the brilliance, restlessness and sophisticated elegance of international Mannerism. The statuette in the illustration clearly derives from Giambologna's *Mercury.*

48 Adrian de Vries. *Mercury and Pandora.* Musée du Louvre, Paris. Another masterpiece by this Flemish artist. Here too the design is clearly derived from those of Giambologna.

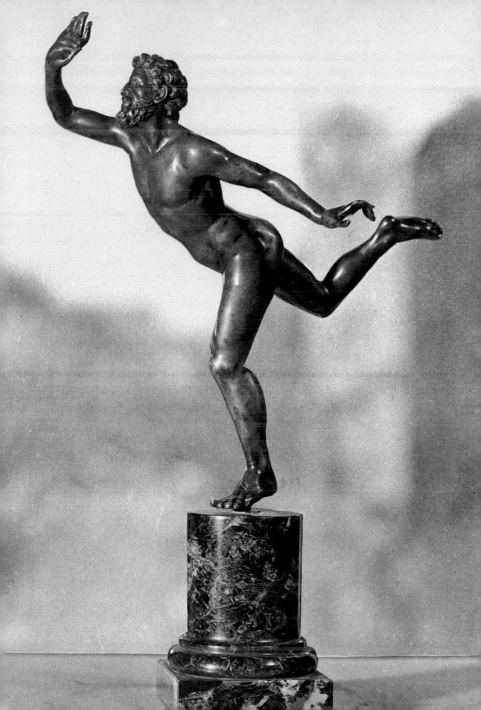

48　Adrian de Vries. *Mercury and Pandora*. Musée du
Louvre, Paris.

predisposition for small bronzes reveals the artist's northern spirit – which was, however, modified by the influence of Florentine sculpture, leading Giambologna to look upon small bronzes primarily as vehicles for the free play of the imagination; a medium in which larger, more abstract ideas as well as natural events might be expressed. Only later, when taste had deteriorated and works of art were regarded as copies of little bits of reality – as though they were 'curiosities' for collectors – did Giambologna also begin to make statuettes of everyday life, figures of bird-catchers, or peasants carrying lanterns. An interest in naturalism had begun in sculpture even before Giambologna, in the form of garden ornaments; and it was with these that the Flemish master began, making various bronze animals for the central grotto of the Medici villa of Castello. He next supervised the making of marble groups with everyday subjects – the *Washerwoman*, the *Reaper*, the *Digging Farmer* and others – which decorated the Giardino di Boboli in the new district next to the Fontana dell'Isolotto. The groups were executed by his pupils and collaborators, of whom the most important was Valerio Cioli, who worked at Boboli from 1599.

Belonging to the same category as these marble and stone groups with their naturalistic subjects are the small genre bronzes made in Giambologna's workshop. He evidently considered them purely decorative objects, of little importance, for he nearly always

delegated this kind of naturalistic work to others. This applies to large-scale sculpture as well as small bronzes.

Mythological or allegorical statuettes, on the other hand, were made largely by the master himself. Examples are *Venus, Mercury* and *Astronomy* (plate 42) in the Kunsthistorisches Museum, Vienna, and *Venus Drying Herself with a Towel, Venus Bathing, Hercules with Club* and *Hercules and the Calydonian Boar*, all in the Bargello, Florence. These statuettes are technically and qualitatively masterpieces of European Mannerism. They represent a development of the formal ideas of late Tuscan Mannerism (above all of Ammannati), rendered with an intense expressiveness and bold rhythms; light and shade effects are used with wonderful skill to enrich the appearance of the metal. Giambologna's complete fidelity to the Italian Mannerist tradition is apparent in the rounded forms of the bodies and the snake-like lines of movement controlled and balanced by the poses. The effect of this contrived, highly intellectual beauty is enhanced by the technical perfection of the casts. These were treated in a special way to ensure that the metal retained its colour (hence the composition of the alloy was of the utmost importance); excessive lustre was avoided by the use of a transparent varnish or fire gilding.

The unusual beauty of Giambologna's statuettes indicates that they were products of his innermost

49 Wenzel Jannitzer. *Spring.* Nearly 3in. Kunsthistorisches Museum, Vienna. The goldsmith and sculptor Wenzel Jannitzer was a native of Vienna; he died at Nuremberg in 1558. His art is related to Italian Mannerism and Cellini in particular.

50 Giovan Francesco Susini. *Boar.* 19in. Museo Nazionale del Bargello, Florence. A small copy of a Greco-Roman original, later used by Pietro Tacca for his *Little pig.*

51 *Virtue Killing Vice.* Florentine, *c.*1570. Musée du Louvre, Paris. Attributed for a time to Cellini, and now to Pierino da Vinci. It seems to me that this bronze, the finest of many replicas, has plastic and linear qualities rather different from those of either artist. This is one of the finest examples of Florentine Mannerism round about 1570, combining the decorative exuberance of the pedestal with a Giambolognesque taste for elegance in the figures.

52 Giovan Francesco Susini. Dying Gladiator. 8in. Museo Nazionale del Bargello, Florence. Signed IO. FR. SUSINI. FLOR. FEC. Susini was a very able foundryman, as is apparent in this statuette. He specialised in small copies of Classical models, exquisite and perfectly finished. This statuette is in fact a copy of the Greek statue in the Museo Capitolini in Rome.

50 Giovan Francesco Susini. *Boar*. 19in. Museo Nazionale
del Bargello, Florence.

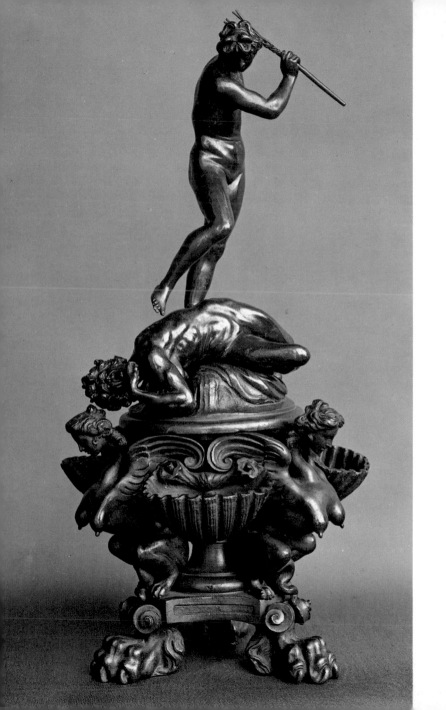

51 *Virtue Killing Vice*. Florentine, *c*.1570. Musée du Louvre, Paris.

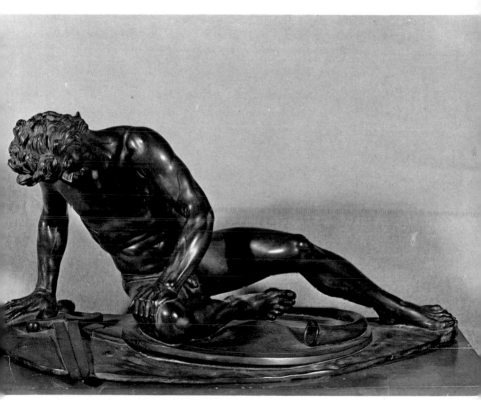

52 Giovan Francesco Susini. *Dying Gladiator*. 8in. Museo Nazionale del Bargello, Florence.

nature. Their principal characteristics were carried over into his monumental work. The result is that his large sculptures have a certain quality of intimacy which combines with their decorative charm to suggest independent, isolated objects like statuettes. Such are the *Neptune* in the Piazza Maggiore in Bologna, raised upon a base encrusted with jewel-like decoration; the *Venus* in the garden of the Petraia villa; and even a marble work such as the *Venus of the Grotticella* (Boboli, Florence). This marked the beginning of a phase in which, from a visual point of view, the statuette was the dominant form of sculpture – not so much in terms of dimensions as by way of internal proportion. Confirmation of this change of roles is to be found in Giambologna's life-size *Mercury* (Bargello, Florence); the boldness and fluency of the movements in relation to space, never before produced on a large scale, has been carried over from the artist's treatment of small bronzes. It is not therefore surprising to find it is very similar to the small *Mercury* in Vienna.

Giambologna was also responsible for the renewed production of religious statuettes. The small bronzes of the Renaissance had been exclusively profane, but during the last twenty years of the 16th century Giambologna turned to religious subjects. He made – or caused to be made – statuettes with such subjects as the *Crucifixion,* the *Virgin and Child* (there is a particularly beautiful example in the Strauss Collec-

tion, New York), the *Pietà* (Virgin with the dead body of Christ), and *Christ Against a Column*, of which there is a magnificent example in the Bargello, Florence (plate 44). The only 16th-century statuettes of a religious character had been the few produced by Jacopo Sansovino in Venice, where the influence of the Counter-Reformation had already been felt. Giambologna's religious works were undoubtedly produced by the same stimulus.

Before about 1580, when the first symptoms of a crisis in Mannerism appeared, the movement achieved a last triumph in the decoration of Francesco I's study in the Palazzo Vecchio. The sculptural decorations in this exquisite room are entirely in bronze; eight magnificent statuettes by various Flemish and Italian artists. They were Giovanni Bandini, known as Giovanni dell'Opera (*Juno*), Ammannati (*Opus*), Giambologna (*Apollo*), Vincenzo Danti (*Venus*), Elia Candido (*Aeolus*), Domenico Poggini (*Pluto*), Vincenzo de' Rossi (*Vulcan*), and Stoldo Lorenzi (*Galatea*). (See plates 56-58). Apart from Giambologna, the only one of these who was primarily a sculptor in bronze was Vincenzo Danti. With the exception of Vincenzo de' Rossi, whose *Vulcan* is an eloquent and sensitive version of Greek naturalism, they all strove to give complete expression to a highly intellectual and sophisticated ideal of beauty based upon exaggerated movements and magnificent but abstract formal conceptions. The perfection of the

finishing and the very light and clear copper-red patina enhanced the mystery of this enchanting art.

Towards the end of the century, there was a stylistic crisis which affected Florentine bronze statuettes, although intensive work continued in Giambologna's workshop (which mainly produced copies of the master's models). The production of Florentine statuettes was maintained – indeed, in the years around the turn of the 16th century it was greater than at any other time. But the small bronzes of this period lacked original inspiration in design and imaginative content; they were hardly affected by the profound transformations that ushered in the new society of the 17th century. This did not apply to the large bronze, at any rate in Florence: the major Tuscan sculptor of the 17th century, Giambologna's pupil Pietro Tacca, worked in the metal.

The small bronze continued to serve a devotional purpose and, most profitably, to meet the demand for imitations of Classical sculpture. In this restricted field, Florentine artists were still imbued with sufficient sensitivity and intelligence to produce more than merely conventional work. Pietro da Barga, for example, has been undeservedly condemned by the critics. He in fact interprets the most straightforward, popular aspect of the Greek revival with genuine and spontaneous feeling, as in his *Flute Player, Bacchus and Satyr, Old Satyr Carrying a Basket of Eggs, Hercules, Silenus and Bacchus* and others, all

53 Antonio Susini. *Bull Killed by a Lion*. 9in. Museo di Palazzo Venezia, Rome.

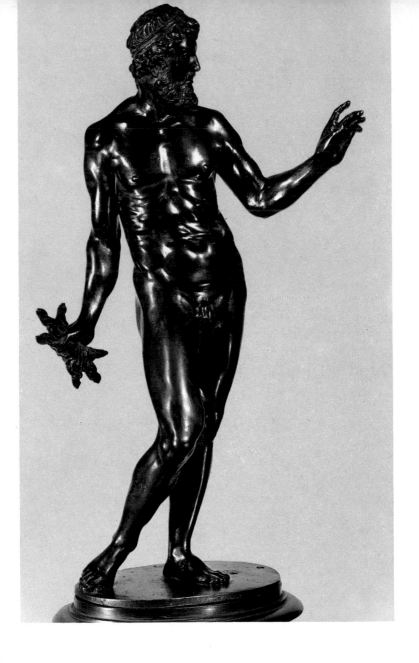

53 Antonio Susini. *Bull Killed by a Lion.* 9in. Museo di Palazzo Venezia, Rome. Light reddish patina. Signed ANT. SUSINI. F. Derives certainly from a Giambologna model, although this is not recorded by Baldinucci. Many replicas are known, both by other artists and in marble.

54 Jacopo Sansovino. *Jove with Thunderbolts.* 17in. Kunsthistorisches Museum, Vienna. Black varnish on natural brown patina. Attributed almost unanimously to Sansovino, this bronze bears a convincing resemblance to works of his Venetian period and in particular the sculptures of the Loggia of St Mark's. Sansovino's small bronzes were justly famous; his 'modern' manner, with its breadth, vigour and colour, gave a new direction to 16th-century Venetian culture.

55 Danaese Cattaneo. *Marine Venus.* 20in. Museo Nazionale del Bargello, Florence. Although it is impossible to be certain that this statuette is from the artist's own hand, it displays Danaese Cattaneo's preference for stronger modelling and a more dynamic articulation than are found in Sansovino's works.

54 Jacopo Sansovino. *Jove with Thunderbolts.* 17in. Kunsthistorisches Museum, Vienna.

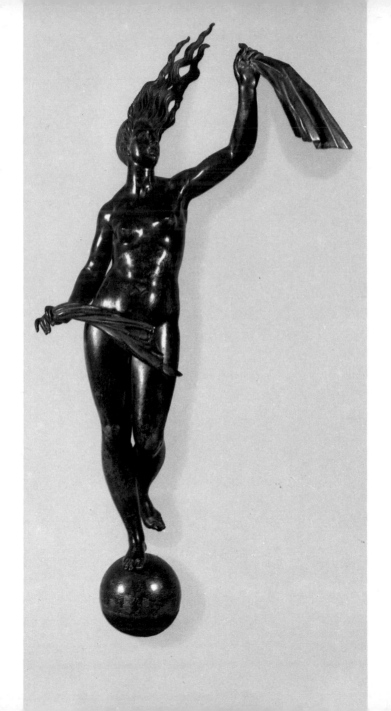

in the Bargello, Florence. They were created between 1575 and 1588 for Cardinal Ferdinando de' Medici, later Ferdinando I. Wishing to make the statuettes look as though they had just been excavated, da Barga left the bronze coarse and rough, giving it a greenish patina in imitation of objects that have been buried for a long time.

The copies of Classical originals made by two of Giambologna's pupils, the brothers Antonio and Francesco Susini, are very different. They specialised in producing small bronzes; when they were not simply using the models and moulds left by the master in his famous Borgo Pinti workshop (they had been his foundrymen during his late period), they made elegant and tasteful copies of antique objects. Examples are the *Horse Killed by a Lion* and *Bull Killed by a Lion* (plate 53), by Antonio (died 1642), which have an exquisite thin red patina. The works of Francesco (died 1646), for example the *Dying Gladiator* (plate 52) and the signed *Ares* (Ashmolean Museum, Oxford) display the same brilliance of casting and patina. They have a discrimination that seems to anticipate the extreme refinement of 18th-century French copies of Classical and Renaissance works. Francesco's *Wild Boar* (plate 50) reveals the same spirit.

Giambologna was a powerful influence on young Flemish artists arriving in Italy, for whom residence in Florence became obligatory. Hence Italian Man-

nerism, and some aspects of the Counter-Reformation, bore the stamp of Giambologna on its arrival in Germany (Adrian de Vries, Jannitzer and Johann G. van der Schardt) in Flanders and, with the arrival in 1601 of one of Giambologna's chief pupils and collaborators, Pietro Francavilla, in France. The diffusion of Italian Mannerism did not, however, take place exclusively through Giambologna's school. It had appeared in France earlier, through Rosso Fiorentino (in 1528) and Primaticcio and Cellini. They brought with them the 'manner' of the young movement – restless and agitated in the case of Rosso, more measured and of exquisite elegance in the case of Primaticcio and Cellini.

During the second half of the century, Mannerism appeared in Spain, where the Aretine artist Leone Leoni (c. 1509-1590) and his son Pompeo worked. (They always collaborated, and their different contributions cannot always be distinguished.) Most of their works were carried out in bronze. Among the best are the many life-size portraits (Prado) of Charles V's family, made between about 1550 and 1555. Their other works include the high altar of the Escorial, Giacomo Medici's tomb in Milan Cathedral, and the seated statue of Vespasiano Gonzaga in Sabbioneta. The manner is that of Bandinelli, formally perfect and severe in expression, and˙is clearly intended to convey the absolute power of the Spanish crown. The precious materials and ornaments

with which these figures are decorated (indicative of Leone's training as a goldsmith) have the same symbolic value.

Apart from the Spanish devotional pieces, such as *Crucifixions* with small figures, Leone's output of statuettes seems to have been disappointingly small. In fact the statuettes that have been attributed to him, among them the versions of the *Fighter* in the Widener Collection in Philadelphia and the Kunsthistorisches Museum in Vienna, leave room for doubt. Only the *Prisoner* (Kunsthistorisches Museum, Vienna) and the *Mars* (Galleria Estense, Modena) correspond in some detail with the large marble figures of the *Omenoni* in the Via Moroni Palace in Milan, and with the *Vespasiano Gonzaga* in Sabbioneta; and neither of these is of much significance in Leone's monumental work.

THE SIXTEENTH CENTURY: VENICE

The sumptuousness, variety and beauty of 16th-century Venetian statuettes are equalled only by those of Florence and the school of Giambologna during the last ten years of the century. The extraordinary impetus which the art of the small bronze received from Riccio lasted a very long time. Riccio's legacy to Venice was twofold: his example fostered the Classical tendencies of artists working during the first ten years of the century; and his inventiveness,

56 Bartolomeo Ammannati, *Opis*. Stoldo Lorenzi, *Galatea*.
Palazzo Vecchio, Florence.

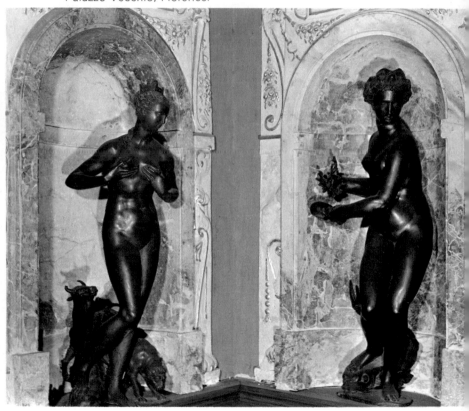

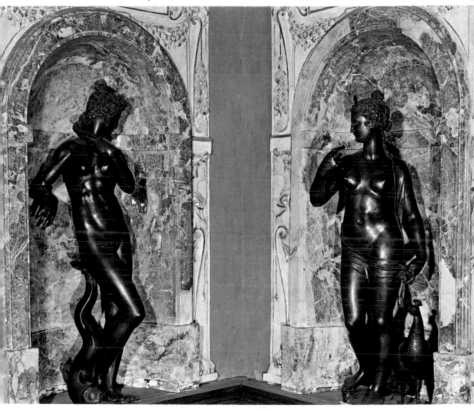

56 Bartolomeo Ammannati, *Opis*. Stoldo Lorenzi, *Galatea*. Palazzo Vecchio, Florence. These bronzes are in the famous study of Francesco I, where the sculptural decorations were all of bronze — a further proof of the Mannerist preference for this metal. Ammannati's statuette is his last work; he gave up sculpture as a result of a religious crisis. Stoldo's is an early work, obviously heavily indebted to Giambologna.

57 Vincenzo Danti, *Venus*. Giovanni Bandini, known as Giovanni dell'Opera, *Juno*. Palazzo Vecchio, Florence. Also part of Francesco I's study. The material, with its fine, clear and brilliant patina, gives an air of mysterious unrest to the elegant bodies.

58 Giovanni Bandini, known as Giovanni dell'Opera. *Juno*. Palazzo Vecchio, Florence. The bronzes made for Francesco I's study mark the culmination of late Italian Mannerism, and all the bronzes are of unsurpassed quality. *Juno,* for example, is Giovanni dell'Opera's masterpiece.

59 Francesco Segala. *Omphale*. 30in. Museo Civico, Padua. Attributed to Ammannati as late as the exhibition of Italian Small Bronzes (1962); it has recently been ascribed to the Paduan Francesco Segala. Venetian and Tuscan statuettes of the second half of the 16th century are easily confused, since both schools stem from Sansovino.

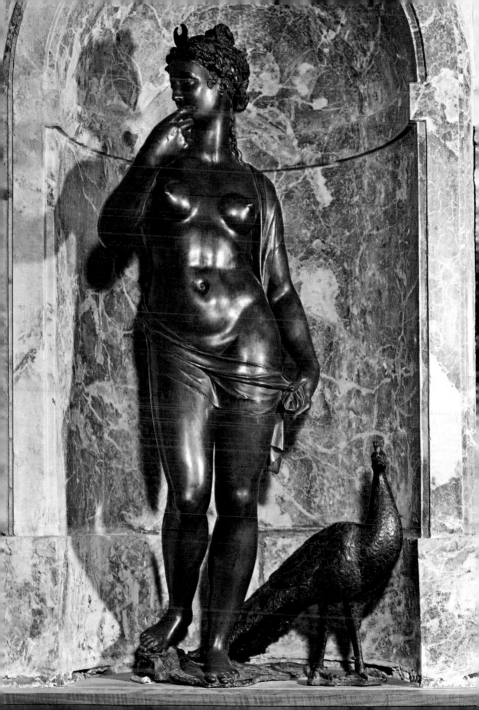

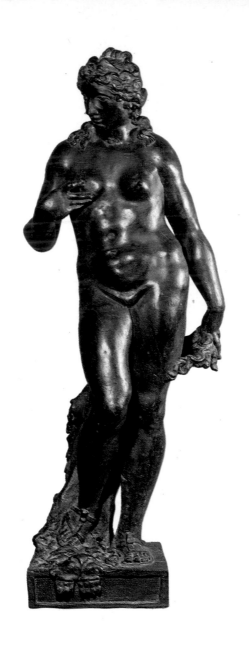

and the practical uses to which he turned the small bronze, were exploited by subsequent generations.

Reference has already been made to the Classical phase of Venetian bronze statuettes during the early part of the 16th century. In the first half of the century (and notably in Venice) there developed what Planiscig described as the style of the 'masters of artificial movement'. Among them he includes Paolo Savin, the sculptor of the figures on the great sarcophagus in the Zen Chapel of St Mark's; the creator of the bronze statuettes generally ascribed to Francesco da Sant' Agata – an attribution that is questionable; Vittore dei Gambelli, known as Vittore Camelio; and Maffeo Olivieri of Brescia. In about 1537 Camelio made two bronze bas-reliefs with battle scenes for his own tomb, which is now in the Museo della Ca d'Oro in Venice; a few small bronzes have been attributed to him, but seldom with much justification. Maffeo Olivieri cast two candelabra for St Mark's in 1527 and may also have been responsible for the so-called *Tubalcain* (Kaiser Friedrich Museum), which is in a somewhat similar style. These artists have one characteristic in common: a tendency to impose artificial movements on their figures, which are running or jumping and are balanced against each other in elaborately-grouped poses. The origins of this movement in Venice are obscure, but are certainly connected with central Italian Mannerism. Classicists and 'masters of the artificial movement' alike none-

Francesco Segala. *Omphale*. 30in. Museo Civico, Padua.

theless retained a local character recognisably derived from Riccio.

Both were swept aside by the arrival in Venice of Jacopo Sansovino (1486-1570). He had already reached maturity and formed his own style; hence his influence was profound and his authority quickly acknowledged. Two fundamental experiences had determined his artistic development. The first had been Classical, deriving from Raphael; Jacopo had undergone it in Rome, towards the end of the first decade of the 16th century, under Andrea Sansovino. The other had been the influence of Michelangelo, in particular of his monumental and plastic values and the vigour of movement of his figures. Sansovino thus brought a Tuscan-Roman style with him to Venice. His residence in Venice brought about a profound stylistic change in the arts of Venezia. In painting it was Tintoretto who was most open to Sansovino's influence; in sculpture it was more widely felt because directly and personally exerted over a number of years: Sansovino worked on the decorations for the small loggia of the *campanile* of St Mark's and for the Libreria Vecchia (1540-*c*.1545), as did nearly all the best young sculptors in Venezia. The result was the astonishing efflorescence of Venetian sculpture in the 16th century, from Danese Cettaneo to Tiziano Minio and Vittoria.

From the time he started working in Venice, Sansovino made use of bronze; he had previously

worked only in marble. Examples of his bronzes are four statues for the niches of the small loggia in St Mark's, and the pulpits and sacristy doors in the same church. At that time no Florentine artist was working in bronze (mainly as a result of Michelangelo's influence); and Sansovino's decision must have been prompted by the Venetian artistic tradition.

One of Sansovino's bronze statuettes is referred to in a letter written by Pietro Aretino, who praises a small *Venus* which the artist had sent him as a present. Quite a large number of statuettes are attributed to Sansovino: the famous *Christ in Limbo* in the Galleria Estense, Modena, though stylistically it belongs to a later period; the *Christ* in the Von Benda Collection in Vienna; and so on. But only two are authenticated. (The four seated statues of the *Evangelists* on the baluster of St Mark's presbytry are not of course independent statuettes.) They are the wonderful *Jove with Thunderbolts* (plate 54) in the Kunsthistorisches Museum, Vienna, and a very lovely *Madonna and Child* in the Cleveland Museum, Ohio. Both are masterpieces; both have breadth of modelling, mellowness, and effects of light and shade of great brilliance. The rhythms of the composition are complex, especially in the *Jove*, which I believe to be a fairly late work; but it is attained with such ease that it appears simple. The facial expressions are tranquil, especially in the *Madonna and Child*. This lessening of the sculptural severity by means of variations in

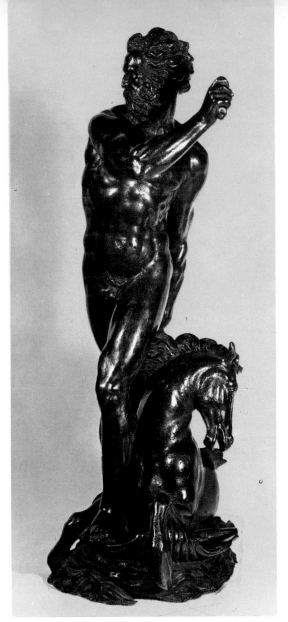

60 Alessandro Vittoria. *Neptune*. 20in. Victoria and Albert Museum, London.

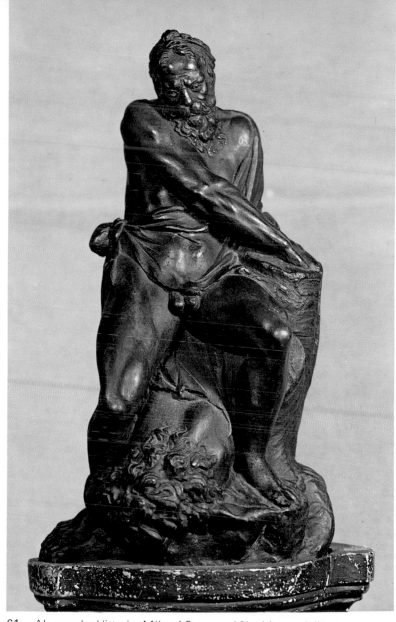

61 Alessandro Vittoria. *Milo of Crotona*. 12in. Museo della
Ca d'Oro, Venice.

60 Alessandro Vittoria. *Neptune.* 20in. Victoria and Albert Museum, London. One of Vittoria's masterpieces. It belongs to his early period and was obviously strongly influenced by Tuscan artists who had worked in Venice (Sansovino, Danaese Cattaneo, Ammannati) The modelling and his design anticipate Bernini's *David.*

61 Alessandro Vittoria. *Milo of Crotona.* 12in. Museo della Ca d'Oro, Venice. This impressive and beautiful bronze belongs to a later stage of Vittoria's development than the *Neptune.* The modelling is accentuated by the skilful use of light and shade effects.

62 Girolamo Campagna. *Kneeling Boy Carrying a Shell.* 8in. Victoria and Albert Museum, London. Gilded; it ocrved as a salt-cellar. The modelling gives the piece a Classical simplicity of design which a Tuscan artist would have achieved by fluidity of movement. There are other examples of inferior quality.

63 Niccolo Roccatagliata. *Cupids Playing.* 10in. Kunsthistorisches Museum, Vienna. Roccatagliata is the last exponent of the great Italian Renaissance tradition of bronze statuettes. In his work the human figure is given decorative value and is full of grace. The cupid was his favourite subject for statuettes.

64 Niccolo Roccatagliata. *Bacchus.* 18in. Victoria and Albert Museum, London. Black varnish on natural brown patina. Although it was made during the first decade of the 17th century, its stylistic affinity with the great Venetian sculpture of the 16th century (and especially with Girolamo Campagna) is plain.

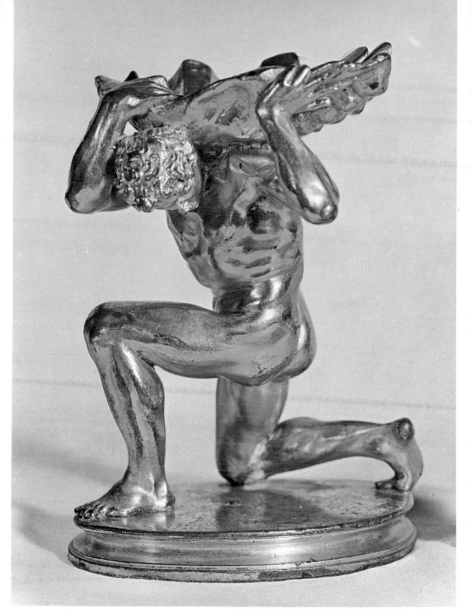

62 Girolamo Campagna. *Kneeling Boy Carrying a Shell.*
8in. Victoria and Albert Museum, London.

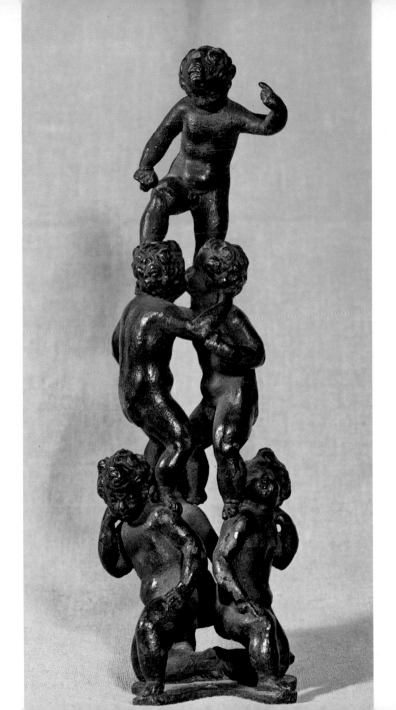

63 Niccolo Roccatagliata. *Cupids Playing*. 10in.
Kunsthistorisches Museum, Vienna.

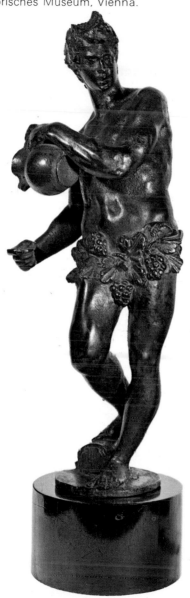

64 Niccolo Roccatagliata. *Bacchus*. 18in. Victoria and
Albert Museum, London.

light and shade testifies to the influence of Venetian art on Sansovino. (In painting the Venetian style already displayed a characteristic lyricism and had attained a position second to none.) Technically, too, Sansovino's small bronzes are typically Venetian, though their black patina is not as thick as it was on Venetian bronzes. There were many variations and copies of the *Jove* and the *Madonna*, which indicates that Sansovino's small bronzes were as much objects of admiration and study as his larger works. All the great Venetian sculptors of the 16th century were deeply influenced by the Tuscan Sansovino, though they proved capable of using the new style to express their personal vision.

The greatest of Sansovino's early collaborators were Danese Cattaneo (who was born in Tuscany but was a Venetian by adoption) and the Paduan Tiziano Minio. Both made small bronzes. Unmistakable stylistic similarities to his major works make it possible to attribute to Cattaneo (1509-1573) the beautiful *Marine Venus* and the *Moon* in the Kunsthistorisches Museum, Vienna. These works show that Cattaneo was the most faithful as well as the most intelligent of Sansovino's followers. They have a greater clarity and vigour of articulation than the Florentine master's statuettes, and this lends more sophistication and elegance to the figures, as well as an extraordinary glowing naturalness that is typically Venetian. These qualities are not, I think, to be

found in the less elegant *Marine Venus* in the Bargello, the limbs of which are extremely elongated. There is also a workshop copy of the *Marine Venus* in the Louvre.

The statuettes attributed to Tiziano Minio (*c.* 1517-1552) are less well-authenticated and are in any case of minor significance. Only the male figure in the Kunsthistorisches Museum, Vienna and the base decorated with fauns' heads and figures of old men in the Bargello are in my view correctly attributed to Tiziano; they display affinities with his major works, and in particular with the bas-relief in the small loggia of St Mark's *campanile* and *Venice Between the Brenta and the Adige*, which represent a fairly early stage of the artist's development. These works reveal Tiziano's temperament, which is characterised by a popular naturalism at once expressive and melancholy. He later assimilated another aspect of Italian Mannerism, that of Parmigianino, and worked with great lyrical power; he then created his masterpiece, the splendid bronze cover for the baptismal font of St Mark's, commissioned in 1545. There are, however, no surviving small bronzes that show any traces of this later experience.

In 1543, Alessandro Vittoria (1525-1608) arrived in Venice from Trento, his native city. He excelled all other Venetian sculptors of the 16th century in originality and imaginative power, in freedom of sculptural expression, and in dramatic eloquence.

His first Venetian works reveal a rich and complex artistic gift. The magnificent *St John the Baptist* in marble (San Zaccaria, Venice) still displays the influence of Sansovino, but it is transformed by a the influence of Sansovino, but it is transformed by a profound and exuberant inspiration, with elongated poses and a play of light and shade which is sometimes extreme and sometimes hardly discernible. There are about ten bronze statuettes by Vittoria that are authenticated by their signature or (more important) by their quality; and innumerable rather crudely-made replicas and workshop copies. Completely authenticated are *Diana*, signed ALEXANDER VICTORIA (Schlossmuseum, Berlin); *Apollo*, with the initials A.V.F. (Kaiser Friedrich Museum, Berlin); *Neptune* (plate 60), unsigned but unmistakeably in Vittoria's style, as are *Jove* and *Winter* (Kunsthistorisches Museum, Vienna); two prophets, signed in full (Von Feist Collection, Berlin); *St Sebastian*, signed and dated 1575 (Bayer Collection, New York); and the folding door with a *Neptune* (Kunsthistorisches Museum, Vienna).

The vigour and complexity of this group is characteristic of Vittoria's art. The *Neptune* and the folding door break with the manner of the Tuscan sculptors Sansovino, Ammannati and Danese Cattaneo, and I am therefore inclined to believe that they were made at about the same time. The *Diana* and *Apollo*, on the other hand, denote a shift towards

the style of Parmigianino; in 1558 Vittoria acquired a book of Parmigianino's drawings and a painting by him, later purchasing similar articles. In these statuettes the figures are greatly elongated and the movement has a controlled grace and elegance. In *Jove, Winter, St Sebastian* and the two prophets in the Feist Collection, the lithe figures are contorted in Mannerist poses to the point of abstraction, seemingly about to dissolve into freedom of form in space. This effect is obtained by the use of zones of light and shade to amplify the modelling; in optical terms, variations on a single chromatic plane (the black varnish on the bronze). In all Vittoria's statuettes the fervour and animation of gesture and facial expression give vitality to the artificial conventions of Mannerism. This vitality and freedom of form prove Vittoria to have been a precursor of Baroque sculpture.

In spite of his striking originality, Vittoria was not the uncontested master of Venetian sculptors in the second half of the 16th century; the influence of Danese Cattaneo was great in both Padua and Verona. To begin with, at any rate, the only artist closely linked with Vittoria was the anonymous but most remarkable 'Master of the Old Men' (Planiscig). The group of bronze statuettes by him, including *Allegory of the World* and *Allegory of the Sea*, in the Kunsthistorisches Museum, Vienna, are executed with a vitality and passion typical of Vittoria. Another follower was the Brescian Andrea Alessandro, who

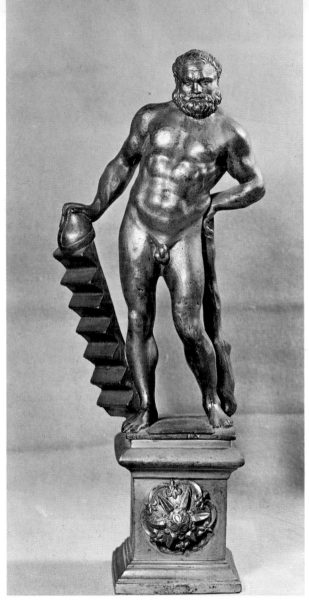

65 *Hercules Gradenigo*. Venetian, mid 16th century. Museo Civico, Padua.

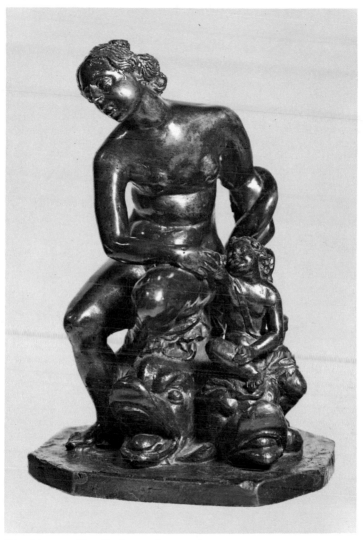

66 *Venus*. 8in. Paduan, first half of the 16th century.
Victoria and Albert Museum, London.

65 *Hercules Gradenigo.* Venetian, mid 16th century. Museo Civico, Padua. For a time attributed to Ammannati, but in fact by a Venetian artist. It is called 'Gradenigo' because Hercules is leaning upon some stairs — an allusion to the coat of arms of the Gradenigo family.

66 *Venus.* 8in. Paduan, first half of the 16th century. Victoria and Albert Museum, London. Dark patina. Pope-Hennessy has recently attempted to attribute it to the circle of Giovanni dell'Opera. The traditional attribution seems right to me, since the piece has a popular, realistic character typical of Padua.

67 Niccolo Roccatagliata. *Three Graces.* Nearly 7in. Galleria Estense, Módena. Attributed for a time to Campagna. It has recently been transferred to Roccatagliata, whose touch can be seen in the exquisite grace which anticipates the small bronzes and porcelains of the 18th century.

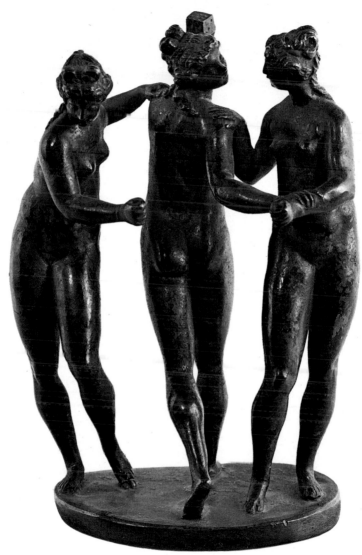

67 Niccolo Roccatagliata. *Three Graces*. Nearly 7in.
Galleria Estense, Modena.

made a richly-figured candelabrum for Sta Maria della Salute in Venice; he shared Vittoria's predilection for decorative elegance.

Danese Cattaneo's greatest Paduan pupil was Francesco Segala (1557-1593), creator of several enchanting bronzes: *St Catherine* (1564) for a stoup for the Santo church in Padua, and *St John the Baptist* (1565) for the baptismal font in St Mark's, Venice. He also did some terracotta sculpture for S. Prosdocimo in Padua. Some small bronzes have been plausibly attributed to him, an *Omphale* and a *Hercules*; there are two examples of these, formerly attributed to Ammannati, in the Museo Civico, Padua and the Berlin Museums.

The final ten years' work of Tiziano Aspetti (1565-1607) demonstrates that the Paduan centre had its own distinct character. Compared with that of contemporaries like Campagna, Aspetti's work is characterised by an emphasis on modelling and forceful expression, a more spontaneous and realistic quality, and a greater capacity for utilising light and shade for expressive effects. These traits, which show that Aspetti was a follower of Tiziano Minio and Danese Cattaneo, are found in both his bronze statuettes and his monumental sculpture. The latter includes *Atalanta* and *Hercules*, both in the Ducal Palace, Venice, and the saints and angels in the Santo Church in Padua. Among his small bronzes are many religious works for the decorations in the

Grimani Chapel in S. Francesco delle Vigne, Venice; and a great many independent, purely decorative statuettes have been attributed to him. The most beautiful are the *Judith* and *Venus* in the Kaiser Friedrich Museum, Berlin, and the folding door with a *Venus* in the Museo Civico at Capodistria. Tiziano Aspetti is an important artist because he helped to spread the free pictorial style characteristic of Venetian sculpture.

Although a pupil of Danese Cattaneo, the Veronese Girolamo Campagna (*c.* 1550-1626) was not a member of the Paduan school. He did not imitate the master's sculptural vigour but preferred a simpler form of modelling, concentrating on the surface and seeking to bring out sculptural values by skilful use of light and shade in accordance with the teaching of Vittoria. Campagna's small bronzes, created during a long and productive career as a monumental sculptor, display a luminous amplification of surfaces which partly eliminates shadow. Veronese's influence on Campagna was important in this respect. The best-authenticated of the small bronzes attributed to Campagna are the fine series of *Angels Carrying the Instruments of the Passion*, which formed part of the high altar of S. Lorenzo in Venice (now in the Museo Correr) and certain utilitarian objects: a salt-cellar in the shape of a kneeling boy bearing a shell (there is an example, reproduced in plate 62, in the Victoria and Albert Museum) and the andirons with *Meleager* and

Atlanta, known in various replicas (the outstanding example is the *Meleager* in the Museo della Ca d'Oro, Venice).

After Campagna, the great Venetian school of bronze statuettes was on the point of extinction. Camillo Mariani (1556-1611), Campagna's greatest pupil and the major Venetian sculptor during the years around the turn of the century, dedicated himself entirely to problems of monumental sculpture. Only one small bronze by him survives, *St Crescentino and the Dragon*, now in the Palazzo del Comune, which used to stand on a column in the Piazza del Comune in Urbino.

Venetian bronze statuettes quickly deteriorated into obscurity and provincialism; but there was a last flowering in the work of the Genoese Niccolo Roccatagliata (documented between 1593 and 1636). Besides ecclesiastical work, Roccatagliata produced a large number of delightful variations on the themes of the cupid and the human figure. Examples are the series of *Amorini* (cupids) in the Kunsthistorisches Museum, Vienna; the two groups of playing *Amorini* in the Museo Correr, Venice; the magnificent andirons in the Museo della Ca d'Oro; and the youthful *Bacchus* in the Victoria and Albert Museum, London (plate 64).

Roccatagliata was one of those splendid exceptions that sometimes occur among the survivors of a great tradition. The new century, during which Rome

became the artistic centre of civilisation, was en-
amoured of size, not to say outsize. Apart from
Duquesnoy's refined Classical pieces and one or two
other exceptional works, there was no longer any
place for the small bronze.

LIST OF ILLUSTRATIONS Page